Gourmet Crochet
A yummy yarn cookbook

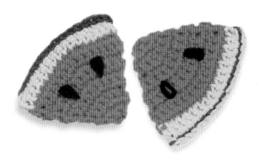

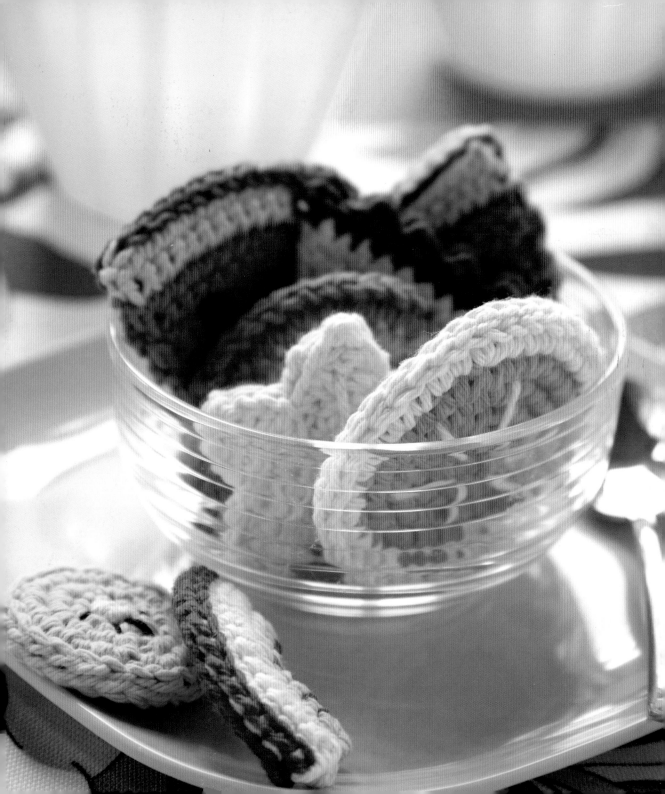

Gourmet Crochet
A yummy yarn cookbook

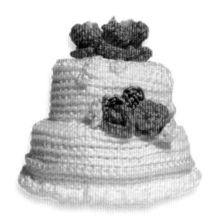

Ivy Press

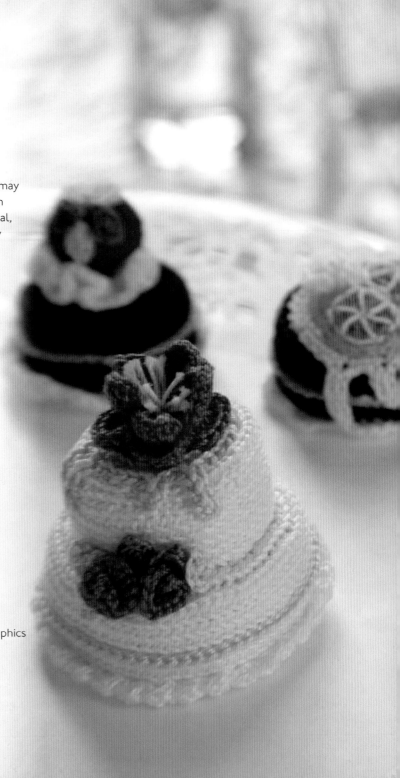

First published in the UK in 2010 by
Ivy Press
210 High Street, Lewes
East Sussex BN7 2NS, UK
www.ivypress.co.uk

British Library Cataloguing-
in-Publication Data
A catalogue record for this book is
available from the British Library

ISBN: 978-1-907332-02-9

This book was conceived,
designed, and produced by
Ivy Press
Creative Director Peter Bridgewater
Publisher Jason Hook
Conceived by Sophie Collins
Editorial Director Tom Kitch
Senior Designer Kate Haynes
Designer Clare Barber
Illustrator Melvyn Evans
Photographer Jeremy Hopley
Additional photography Neal Grundy

Colour origination by Ivy Press Reprographics

10 9 8 7 6 5 4 3

Printed in China

Contents

Introduction

Life is uncertain. Eat dessert first.

Ernestine Ulmer

The amigurumi world isn't solely populated by strange little characters made of yarn. There are plenty of other enthusiasms realized in this alternative woollen universe – and one of the most popular is the re-creation of food of every kind (from tiny pieces of candy to full meals) in crochet. This book takes the craze and runs with it: whether your taste is for a fancy gâteau or a simple BLT sandwich, you'll find something to suit both your palate and your hook in the pages that follow. Patterns are arranged by menu so you can pick a sushi platter or a dim sum basket, some wholesome fresh fruit or a platter of crudités, or even an artisanal cheese board with two kinds of crackers and a convincing bottle of wine.

All of these 'yummy 'gurumi' patterns are straightforward for anyone who has some experience in crochet; if you're a novice, practise a few of the basic stitches on the following pages and start with some of the simpler fruit and vegetable patterns in the Natural Goodness chapter, or the sushi selection in the Global Treats chapter. Take your time in finishing the pieces, too – they're small enough for it to matter and they'll look more polished and more realistic if they're filled evenly and the ends are finished off invisibly.

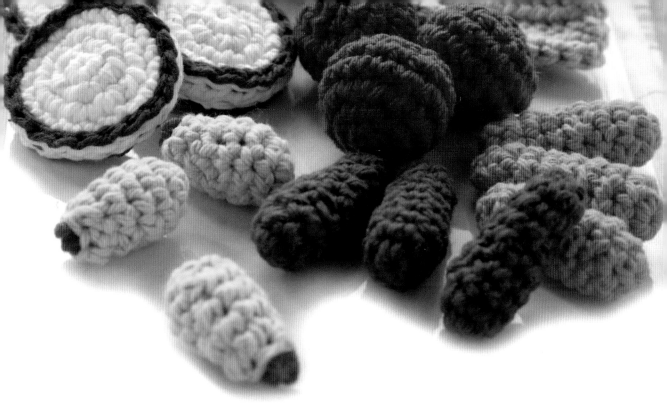

If you like the idea of crocheting up a few of your favourite food treats but aren't so keen on purely decorative projects, you can press many of these patterns into practical service too. The teeny crochet cakes make cute-as-a-button key fobs while an apple makes a good pincushion. Any of the pieces that need stuffing can be filled with dried lavender flowers and popped into a drawer to keep clothes moths at bay. If you're giving yummies as gifts (or displaying your work), adding a bit of authenticity is great too: group your creations together and present a fruit salad in a cut-glass bowl, or a variety of dim sum in a bamboo steamer. But watch out: with all the appetizing qualities of the real foods but none of the calories, making amigurumi treats can become addictive.

Basic crochet know-how

Making most of the foods on these pages won't be hard if you have basic crocheting skills. If you're a novice, crochet is quite easy to learn and the basic steps are shown on these pages. Start with some of the simpler designs (the nigiri sushi on pages 34–9 are very straightforward). The patterns are worked in either rows, for squared-off shapes with corners, or rounds, for rounded ones.

WHAT YOU NEED

Each pattern in this book has an ingredients list at the start that includes everything you need. Yarn for the patterns can be switched around, provided you stick with the same basic weight of yarn (for example, the fruit pieces have been made in a cotton yarn, but you could make these equally well in wool provided that you pick one in a DK weight).

The patterns do not give yarn quantities because the amounts of yarn needed are very small – usually far less than a 50 g (1 ¾ oz) ball of DK-weight yarn. If you're new to crochet (and don't have a yarn bag full of ends and scraps yet), we suggest that you buy complete balls of yarn for your first couple of projects to give yourself an idea of how much you'll need, then move on to odds and ends of yarn as you grow more familiar with the amounts you're expecting to use.

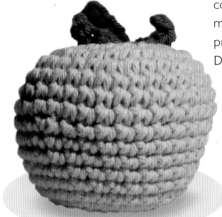

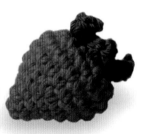

Crochet stitches

HOW TO MAKE A FOUNDATION CHAIN

This is the starting point of all crochet patterns.

1 Make a slip knot by making a loop, then hook the length of yarn through it with your hook and pull to tighten.

2 Start a foundation chain by bringing the yarn back over the hook from the back to the front and grabbing it with the

hook. Draw the yarn through the knot and onto the hook to make your first chain stitch. Repeat to add stitches to the chain.

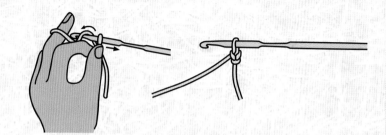

HOW TO INCREASE (inc)

To increase, you need to work two stitches into the first stitch of a row. Work the first stitch as usual, then use your hook to pull an extra stitch through the loop beneath.

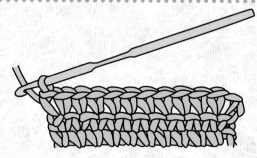

HOW TO DECREASE (dec)

Draw up two loops onto your hook (adding to the stitch already on the hook) by feeding the hook through the next two stitches in line. With three loops on the hook, place your yarn over the hook and draw it through all three loops to decrease one stitch.

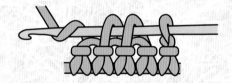

SLIP STITCH (sl st)

Slip stitch is the most basic crochet stitch of all. It is particularly useful for finishing off edges or joining pieces together.

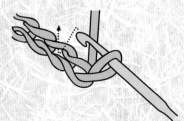

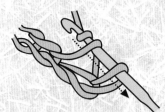

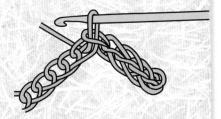

1 Start with a foundation chain. Insert the hook into the second chain from the hook or the next stitch and hook the yarn.

2 Draw through the chain and loop already on the hook to make one slip stitch.

3 Continue working into the next stitch in the row.

DOUBLE CROCHET (dc)

Insert the hook into the next chain or stitch and hook the yarn. Draw the yarn through the first loop on the hook. Hook the yarn again and draw the yarn through the two loops.

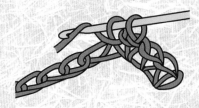

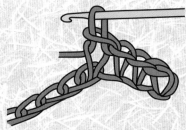

TREBLE CROCHET (tr)

1 Loop the yarn over the hook, then insert the hook into the next stitch.

2 loop the yarn over the hook and pull the yarn through the stitch.

3 Loop the yarn over the hook, pull it through two loops on the hook, then loop the yarn over a final time and pull it through the last two loops on the hook to complete one treble crochet.

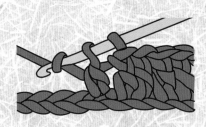

HALF-TREBLE CROCHET (htr)

Put the yarn over the hook. Insert the hook into the third chain or next stitch to be worked, place the yarn over the hook again and pull it through the loop.

Place the yarn over the hook again, then pull it through all three loops on the hook. This makes one half-treble crochet stitch.

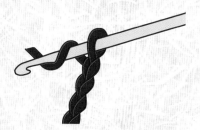 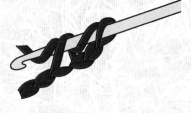 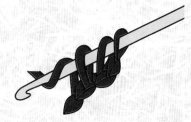

DOUBLE TREBLE CROCHET (dtr)

1 Loop the yarn over the hook twice, then insert the hook into the next stitch (there will be four loops on the hook).

2 Loop the yarn over the hook and draw it through two loops, leaving three loops remaining, then loop the yarn over the hook again and draw through two loops.

3 Finally, loop the yarn over the hook and draw it through the last two loops on the hook to complete one double treble crochet.

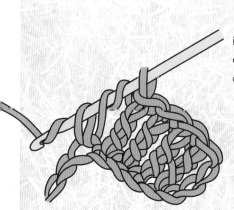

TRIPLE TREBLE CROCHET (trtr) AND QUADRUPLE TREBLE CROCHET (quad tr)

For triple treble crochet, simply follow the instructions for double treble crochet but loop the yarn over the hook three times in step 1, then loop the yarn and draw it through two loops one additional time in step 2. For quadruple treble crochet, loop the yarn four times in step 1, then loop the yarn and draw it through two loops twice more in step 2.

MAKING A MAGIC RING

This is a method of crocheting in rounds in a neat, tight circle without leaving a central hole.

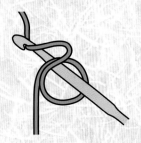

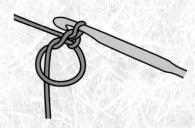

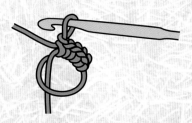

1 Make a large circle with your yarn, leaving a trailing tail, then use the hook to draw the working yarn through both the circle and tail strand held together. This creates one loop.

2 With this loop, chain one stitch to begin the magic ring.

3 Continue making single crochet stitches around the ring, following the number of stitches required for the pattern until you have worked a full circle. Pull the tail of the yarn to close the ring and make a tight round.

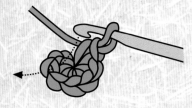

4 Begin your second round by crocheting into the first stitch of the first round. You can use a paper clip or a stitch marker to mark the beginning of the new round.

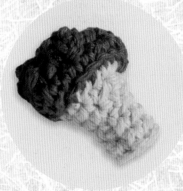

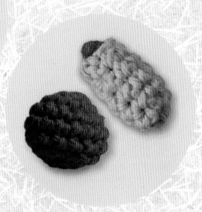

Making up the patterns

Putting the food pieces together isn't difficult, but a neat finish adds greatly to the charm of the end result.

STUFFING

Unless another material is specifically suggested for a particular pattern, use custom-made toy stuffing. These are light, soft and easy to use, and will result in an evenly padded, squeezable piece. Some alternatives, such as cotton balls, will make the finished piece feel hard or lumpy. Pack the stuffing in small pieces, using the end of a crochet hook to help you to distribute it evenly and to push stuffing into the corners.

SEWING CROCHET PIECES TOGETHER

You can use yarn, sewing thread or even embroidery floss to sew your yummi 'gurumi together. If you choose to use the leftover tails of yarn from crocheting, use a yarn needle; you will probably need an embroidery or sewing needle if you use sewing thread or floss. Most of the patterns in the book are sewn together with whipstitch (see below). Sew any ends of yarn or thread into the centre of the piece for a neat finish.

EMBROIDERY STITCHES

Standard embroidery floss comes in a small skein. The thread is made up of six separate strands; most of the patterns here call for the full thickness of floss to be used, but if you need a finer thread, you can pull the strands apart to get the thickness you want. A few of the food pieces also use embroidery stitches, and instructions for these follow.

Stitches

WHIPSTITCH

Whipstitch is used to attach two pieces of crochet together. To whipstitch, thread your needle with yarn or thread and align the two pieces of crochet. Take the needle through both thicknesses of yarn and make a small stitch at right angles to the crocheted fabric. Push the needle through the yarn, then bring it up at right angles again and repeat the stitch. This is a practical rather than a decorative stitch, so use matching thread or yarn and make it as unobtrusive as possible.

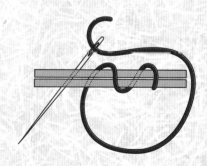

BACKSTITCH

This stitch makes a plain, solid line.

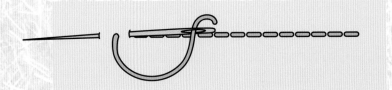

1 Thread a needle with yarn or thread, whichever is specified. Bring it up through the fabric at the point at which you want the line of stitching to start.

2 Make a stitch going the opposite way from the way you want your backstitch line to continue, and bring the needle back up through the fabric one stitch length away in the direction in which you want your stitching to go.

3 Take the thread backwards and push the needle through the point where the first stitch finished. Bring it out again the same distance (one stitch length) in front of the thread. Continue in the same way until the length of the desired line of backstitch is complete.

CHAIN STITCH

This stitch makes a decorative row of linked loops, rather like a row of crochet pressed flat.

1 Bring your needle up through the fabric, then bring the spare thread out in front of the needle and make a loop around it. Reinsert your needle in the fabric and bring it out again one stitch length in front of your first stitch, and through the loop of thread.

2 Pull the thread tight to make an oval-shaped stitch. Repeat both steps to make a chain of linked stitches.

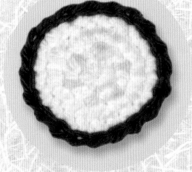

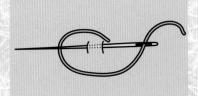

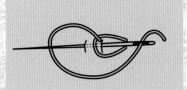

FRENCH KNOT

This stitch makes a small, decorative knot that stands above the surface of the yarn or fabric.

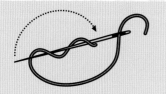
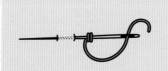

1 Thread the needle with a length of yarn or floss, fasten the end, and bring it out at the point at which you want to make your French knot. With your left thumb, hold the thread down at the point at which it emerges from the fabric and wrap it twice around the needle.

2 Keeping your thumb in place on the fabric, bring the needle back to the starting point and put the point back through the fabric very near to where it emerged (not in the exact same spot, though, or the thread will simply pull back through the hole).

3 Pull the needle through to the back of the fabric and pull taut. This will leave a small, textured knot. Tie off the thread at the back or go on to make the next French knot.

BEADING

If you want to add beaded details to your work, always remember to use a beading needle – if you forget and use an embroidery needle, there will be a moment of intense frustration when you find that the needle won't fit through the tiniest bead.

Beads are very easy to sew on to your yummi 'gurumi. Simply bring the needle through from the back of the fabric, thread the bead onto the needle, and then push the needle back through near the original place it emerged and pull the thread tight.

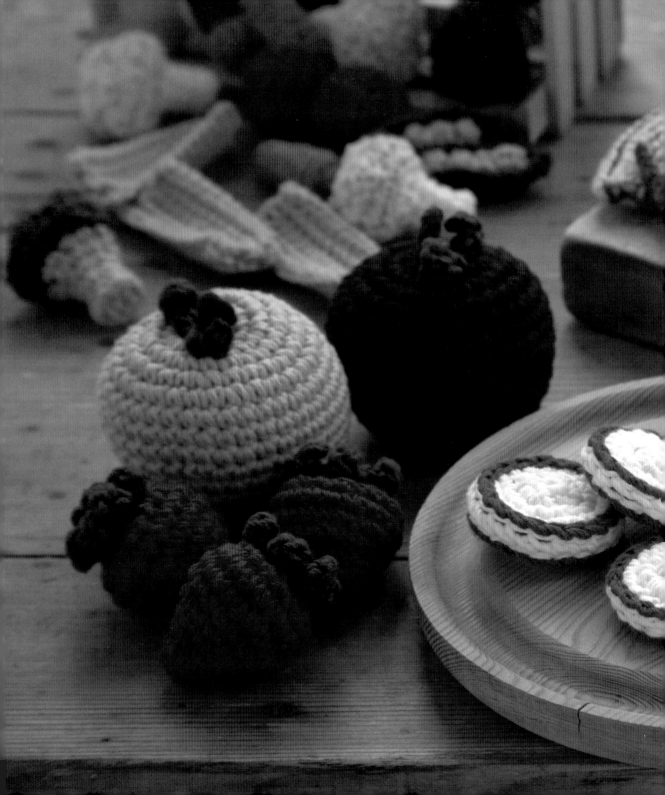

Menu

NATURAL GOODNESS

FRUIT SALAD

Apple, strawberry, watermelon, persimmon,
kiwi, peach, starfruit, orange and pineapple

VEGETABLE DIP

Broccoli, cauliflower, carrot, cornichon,
cucumber, olive, tomato, celery and pea pod
Bowl of sour cream dip

Fruit salad

Fancy a refreshing bowl of fruit? The fruit salad here should meet most of your vitamin C needs for the day – if intake can be measured in yarn, that is. The fruits shown here have been worked in DK-weight cotton yarn, but wool or wool-mix will work just as well provided that it's a DK weight.

INGREDIENTS

- 3.5 mm (US size E) crochet hook
- DK-weight yarn in the suggested colours (*each pattern calls for only a small amount of each colour of yarn*)
- Tapestry needle (*for weaving in yarn ends and sewing up seams*)
- Scissors
- Some pieces need a little stuffing – choose a lightweight custom toy stuffing

PATTERN TENSION

Using DK-weight yarn and a 3.5 mm (US size E) crochet hook, 5 dc x 5 rows = 2.5 cm x 2.5 cm (1" x 1")

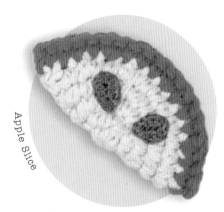

Apple Slice

APPLE SLICE

Do you prefer your apples green or red? You can make this in either colour or perhaps make a mixture. If you want a green apple, just exchange the red yarn for green.

YOU ALSO WILL NEED

- Small quantities of DK-weight yarn in ecru and red
- Dark red six-strand embroidery floss (*you will be using all six strands*)
- Embroidery needle

RND 1 using ecru yarn, dc 6 in magic ring, sl st to close round {6 dc sts}

RND 2 ch 1, dc 1 in same space as prev. sl st, [dc 2 in next st] all round, sl st to close {11 dc sts}

RND 3 ch 1, dc 2 in next st, dc 2 in next st, [dc 1, dc 2 in next st, dc 2 in next st], sl st to close {19 dc sts}

RND 4 ch 1, dc 3, dc 2 in next st, [dc 4, dc 2 in next st], sl st to close round {23 dc sts}

RND 5 ch 1, dc 1, dc 2 in next st, [dc 2, dc 2 in next st], clean colour change sl st to close round {31 dc sts}

RND 6 using red yarn, ch 1, dc 2, dc 2 in next st, [dc 3, dc 2 in next st], clean cast off {39 dc sts}

TO MAKE UP THE APPLE SLICE
Weave in any loose ends on the wrong side of fabric. Fold the apple slice in half and whipstitch all round the edge in red yarn. Stitch 'pips' onto the slice, using single stitches overlaying one another to make the slightly raised shape, and using the photograph to place them correctly.

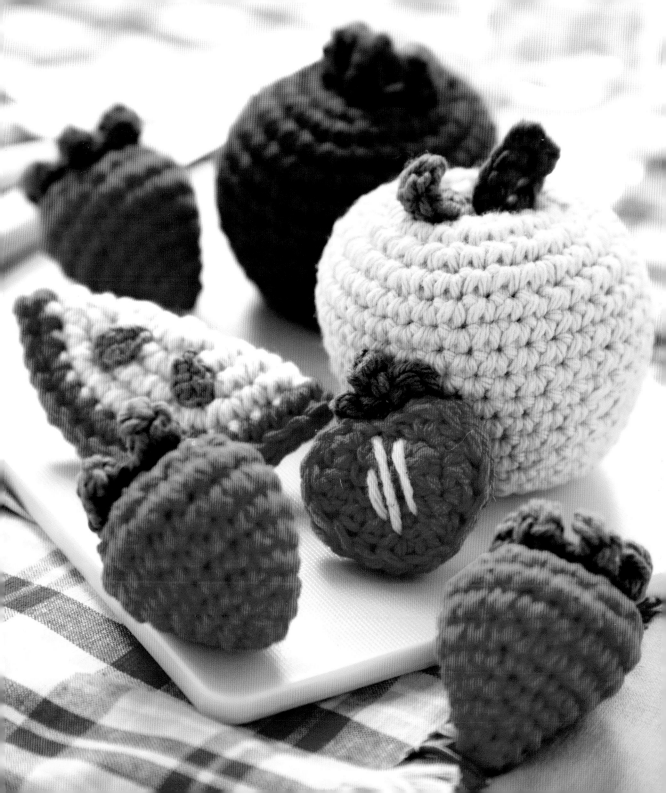

WHOLE APPLE

A whole bowlful of these can be deceptively lifelike at first glance, and makes a cute ornament for your flat or house.

YOU ALSO WILL NEED

• Small quantities of DK-weight yarn in bright green or wine (*depending on whether you want to make a green or a deep red apple*), dark green and brown

RND 1 using either bright green or wine yarn, dc 6 in magic ring, continue all round in a spiral {6 dc sts}

RND 2 [inc in next st] all round {12 dc sts}

RND 3 [dc 1, inc in next st] all round {18 dc sts}

RND 4 [dc 2, inc in next st] all round {24 dc sts}

RND 5 [dc 3, inc in next st] all round {30 dc sts}

RND 6 [dc 4, inc in next st] all round {36 dc sts}

RNDS 7–9 dc all round {36 dc sts}

RND 10 [dc 10, dec 1 st over 2] all round {33 dc sts}

RNDS 11 AND 12 dc all round {33 dc sts}

RND 13 [dc 9, dec 1 st over 2] all round {30 dc sts}

RND 14 dc all round {30 dc sts}

RND 15 [dc 8, dec 1 st over 2] all round {27 dc sts}

RND 16 [dc 3, dec 1 st over 2, dc 2, dec 1 st over 2] all round {21 dc sts}

RND 17 [3-tr cluster over next 3 sts] all round, cut yarn leaving a long tail

TO MAKE UP THE APPLE
Fill it with stuffing, padding it so that it feels firm but not hard. Stitch all round the open edge using the leftover tail of yarn and pull the yarn taut to close up the opening. Thread your tapestry needle with a piece of yarn that matches your fruit's main colour and stitch up through the centre of the apple's base (round 17) and out through the centre of the apple's top (round 1). Pull this yarn so that it is tight enough to leave a dimple at the top and bottom of the apple. Weave in the yarn ends so the yarn holds the dimple in place. If the apple is firmly filled, you should be able to shape it slightly with your hands.

APPLE STEM
(*make 1, using brown yarn*)
h 6, sl st 1, ch 1, sl st 1 in same space as prev. sl st, sl st over next 4 sts.

Cut the yarn, and pull loose yarn ends through the centre of Round 1 of the apple. Sew into place with needle and thread.

APPLE LEAF
(*make 1, using dark green yarn*)
[Ch 6, sl st 1, dc 1, tr 2, sl st 1] twice. Cut the yarn, and pull loose yarn ends though the centre of Round 1 of the apple. Sew into place with needle and thread.

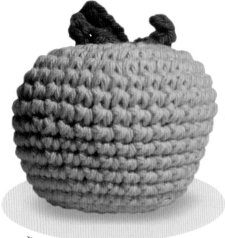

Whole Apple

WHOLE STRAWBERRY

Like whole apples, these look best grouped together in a small bowl.

YOU ALSO WILL NEED

- Small quantities of DK-weight yarn in bright red and dark green
- Sewing needle and dark green thread

RND 1 using red yarn, dc 6 in magic ring, continue all round in a spiral {6 dc sts}

RND 2 [dc 1, inc in next st] all round {9 dc sts}

RND 3 [dc 2, inc in next st] all round {12 dc sts}

RND 4 [dc 3, inc in next st] all round {15 dc sts}

RND 5 [dc 2, inc in next st, dc 1, dec 1st over 2] all round {21 dc sts}

RNDS 6 AND 7 dc all round {21 dc sts}

RND 8 [dc 2, dec 1st over 2, dc 1, dec 1st over 2] all round {15 dc sts}

RND 9 [dc 1, dec 1st over 2, dec 1st over 2] all round, cut yarn leaving a long tail

TO MAKE UP THE STRAWBERRY

Fill the strawberry body with stuffing until it feels firm but not hard. Use the tail of the yarn to stitch loosely all round the open edge, then pull the yarn tight to close the opening up with dc 9. {9 dc sts}

STRAWBERRY LEAVES

(make 1 for each strawberry)

RND 1 using dark green yarn, dc 6 in magic ring, sl st to close round {6 dc sts}

RND 2 [[ch 4, sl st 1, dc 2] in next chain, sl st 1 in round] 6 times, cast off {6 'ch 4' points}

Pull the yarn ends left from the top piece through the opening of the main strawberry piece. Sew into place with a needle and thread.

STRAWBERRY SLICE

(make 2 pieces for each slice)

This strawberry still has its leaves to keep it looking fresh.

YOU ALSO WILL NEED

- Small quantities of DK-weight yarn in bright red, dark green and ecru

RND 1 using bright red yarn, ch 5, htr 1 two chain from hook, tr 2 in next st, dc 1, sl st 1, ch 1, sl st 1 in same space as prev. sl st, continuing all round other side of chain, dc 1, tr 2 in next st, htr 1, sl st in first htr to close round

RND 2 ch 1, [dc 1, htr 1] in next st, tr 2 in next st, htr 2, dc 1, ch 1, dc 1, htr 2, tr 2 in next st, [htr 1, dc 1] in 1, clean cast off

STRAWBERRY LEAVES

(make 1 for each slice)

Using dark green yarn, ch 3, sl st 2, ch 2, sl st 2, ch 2, sl st 2, cast off.

TO MAKE UP THE STRAWBERRY SLICE

Sandwich the two together, right sides out, with the base of the leaf piece sandwiched between them, and whipstitch all round the edges in red yarn. Thread a tapestry needle with ecru yarn and make three single stitches vertically on the slice. Finish off the yarn invisibly in the middle of the slice.

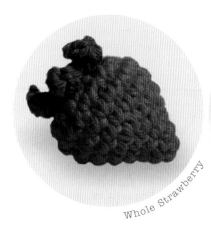

Whole Strawberry

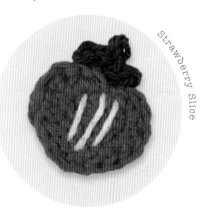

Strawberry Slice

TROPICAL FRUIT

Maybe apples and strawberries
are a bit too commonplace for
your fruit salad? If you like a more
exotic mix, try this selection –
featuring everything from
pineapple to starfruit, all sliced
up and ready for the bowl.

WATERMELON SLICE

(make 2 pieces for each slice)
This juicy, bright pink fruit seems
to drip with flavour. But don't
choke on the seeds!

YOU ALSO WILL NEED

• Small quantities of DK-weight
 yarn in bright pink, bright green
 and dark green
• A small scrap of black felt or a
 short length of black DK-weight
 yarn (for the watermelon 'seeds')

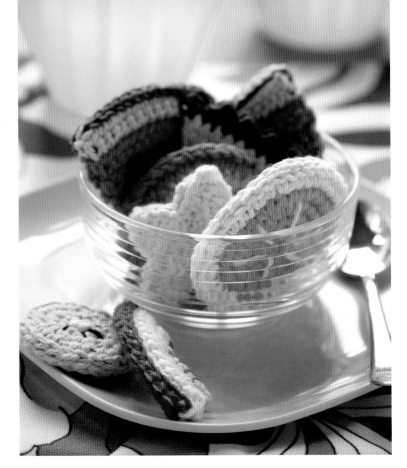

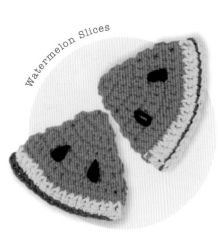

Watermelon Slices

ROW 1 using bright pink yarn, ch 2, dc 2 in first ch st {2 dc sts}

ROW 2 ch 1, turn, [dc 2 in next st] twice {4 dc sts}

ROW 3 ch 1, turn, [dc 1, dc 2 in next st] twice {6 dc sts}

ROW 4 ch 1, turn, dc across {6 dc sts}

ROW 5 ch 1, turn, [dc 2, dc 2 in next st] twice {8 dc sts}

ROW 6 ch 1, turn, [dc 3, dc 2 in next st] twice {10 dc sts}

ROW 7 ch 1, turn, dc across {10 dc sts}

ROW 8 ch 1, turn, [dc 2 in next st, dc 4] twice {12 dc sts}

ROW 9 ch 1, turn, [dc 2 in next st, dc 5] twice {14 dc sts}

ROW 10 ch 1, turn, [dc 2 in next st, dc 6] twice {16 dc sts}

ROW 11 using bright green yarn, ch 1, turn, dc across {16 dc sts}

ROW 12 ch 1, turn, dc across, making each stitch in the following manner {16 dc sts}

Pull the first loop of the dc through, using bright green yarn, and make the second loop of the

stitch using dark green yarn. If you want a thicker rind, make all of the dc stitches in this row using dark-green yarn – this will give you a wider green stripe. Cast off.

TO MAKE UP THE WATERMELON SLICE
When you have made a second piece, align the two pieces of crochet, right sides out, and whipstitch them together using matching yarn. Either cut small watermelon seeds in black felt and stitch them to the slice (see photograph of the finished piece for placement of the seeds) or, alternatively, use black yarn to embroider on seeds with large, overlaid stitches to give them a little texture.

PERSIMMON SLICE

Sour-tasting when it's green, a persimmon ripens to a luscious orange-pink.

YOU ALSO WILL NEED
• Small quantities of DK-weight yarn in bright orange and bright pink

RND 1 using bright orange yarn, dc 6 in magic ring, sl st to close round {6 dc sts}
RND 2 ch 1, dc 1 in same space as prev. sl st, [dc 2 in next st] all round, sl st to close {11 dc sts}

RND 3 ch 1, dc 2 in next st, dc 2 in next st, [dc 1, dc 2 in next st, dc 2 in next st] 3 times, sl st to close {19 dc sts}
RND 4 ch 1, dc 3, dc 2 in next st, [dc 4, dc 2 in next st] 3 times, sl st to close round {23 dc sts}
RND 5 ch 1, dc 1, dc 2 in next st, [dc 2, dc 2 in next st] 3 times, clean colour change sl st to close round {31 dc sts}
RND 6 using bright pink, ch 1, dc 2, dc 2 st in next st, [dc 3, dc 2 st in next st], clean cast off {39 dc sts}

TO MAKE UP THE PERSIMMON SLICE
Fold the crochet piece in half, right side out, and whipstitch the edge closed in bright pink yarn. Make two stitches in the orange area of your segment – check the photograph of the finished piece for placement. Finish off the yarn invisibly in the middle of the slice.

KIWI SLICE

(make 2 pieces for each slice)
The sharp, acidic green of a slice of kiwi fruit will give your salad some extra pizazz.

YOU ALSO WILL NEED
• Small quantities of DK-weight yarn in bright green and ecru
• Black six-strand embroidery floss (*you will be using all six strands*)
• Embroidery needle

RND 1 using ecru yarn, dc 6 in magic ring, clean colour change sl to close round {6 dc sts}
RND 2 using bright green yarn, ch 1, dc 1 in same space as prev. sl st, [dc 2 in next st] all round, sl st to close round {11 dc sts}
RND 3 ch 1, dc 2 in next st, [dc 1, dc 2 in next st] all round, sl st to close round {17 dc sts}
RND 4 ch 1, dc 1, dc 2 in next st, [dc 2, dc 2 in next st] all round, clean cast off {23 dc sts}

TO MAKE UP THE KIWI SLICE
When you have made the second piece, align the two pieces, right sides out, and whipstitch them together using matching yarn. Thread an embroidery needle with black floss and make six long stitches at intervals from the centre of the slice towards the edge, checking the photograph for placement. Finish the thread off invisibly in the centre of the slice.

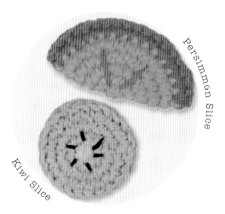

Persimmon Slice

Kiwi Slice

PEACH SLICE

(make 2 pieces for each slice)
The pastel tones of a ripe peach slice strike a gentle note among the more tropical treats.

YOU ALSO WILL NEED

• Small quantities of DK-weight yarn in peach, yellow and bright red

ROW 1 using peach yarn, ch 8, [dc 2 in next st, dc 1] 3 times, dc 2 in next st {11 dc sts}

ROW 2 using yellow yarn, ch 1, turn, dc across {11 dc sts}

ROW 3 ch 1, turn, [dc 2, dc 2 in next st] 3 times, dc 2 {14 dc sts}

ROW 4 using red yarn, ch 1, turn, dc across, making each stitch in the following manner {14 dc sts}

Pull the first loop of the dc through using yellow yarn, and make the second loop of the stitch using red yarn. If you find this confusing or tricky, simply make all of the dc stitches in this row using red yarn – this will make the skin of your peach look slightly thicker, cast off.

TO MAKE UP THE PEACH SLICE

When you have made a second piece, align the two pieces of crochet together, right sides facing out, and whipstitch them together with matching yarn.

STARFRUIT SLICE

(make 2 pieces for each slice)
With its unusual shape, this fruit will add variety to your bowl.

YOU ALSO WILL NEED

• Small quantities of DK-weight yarn in yellow and ecru

RND 1 using yellow yarn, dc 5 in magic ring, sl st to close round {5 dc sts}

RND 2 ch 1, dc 1 in same space as prev. sl st, [dc 2 in next st] all round, sl st to close {9 dc sts}

RND 3 ch 1, dc 1 in same space as prev. sl st, [dc 2 in next st] all round, sl st to close {19 dc sts}

RND 4 [ch 4, sl st 1 in chain, dtr 2 in chain, miss 3 in main round, sl st 1 in main round] 5 times, cast off. {5 'ch 4' points}

TO MAKE UP THE STARFRUIT SLICE

Align the two pieces, right sides out, and whipstitch them together using yellow yarn. Thread a tapestry needle with ecru yarn and make five long single stitches on the slice, starting each one close to the middle of the slice and stitching outwards, almost to one of the outer points. Then finish off the yarn and sew the end invisibly between the two sides of the slice.

ORANGE SEGMENT

For the orange segment, you make a single piece and fold it.

YOU ALSO WILL NEED

• Small quantities of DK-weight yarn in orange and yellow

RND 1 using orange yarn, dc 6 in magic ring, sl st to close round {6 dc sts}

RND 2 ch 1, dc 1 in same space as prev. sl st, [dc 2 in next st] all round, sl st to close {11 dc sts}

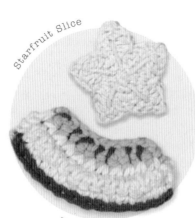

Starfruit Slice

Peach Slice

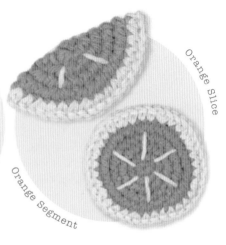

Orange Slice

Orange Segment

RND 3 ch 1, dc 2 in next st, dc 2 in next st, [dc 1, dc 2 in next st, dc 2 in next st] 3 times, sl st to close {19 dc sts}

RND 4 ch 1, dc 3, dc 2 in next st, [dc 4, dc 2 in next st] 3 times, sl st to close round {23 dc sts}

RND 5 ch 1, dc 1, dc 2 in next st, [dc 2, dc 2 st in next st] 7 times, clean colour change sl st to close round {31 dc sts}

RND 6 using yellow yarn, ch 1, dc 2, dc 2 in next st, [dc 3, dc 2 in next st] 7 times, clean cast off {39 dc sts}

TO MAKE UP THE ORANGE SEGMENT

Fold the crochet piece in half and whipstitch the edges closed with matching yellow yarn. Thread a tapestry needle with yellow yarn and make two stitches on the orange area of your segment – check the photograph for placement. Finish off the yarn invisibly in the middle of the slice.

ORANGE SLICE

(make 2 pieces for each slice)

Orange slices look great arranged with orange segments.

YOU ALSO WILL NEED

• Small quantities of DK-weight yarn in orange and yellow

Follow the instructions for the orange segment to the end of Round 6.

TO MAKE UP THE ORANGE SLICE

Align both pieces, right sides out, and whipstitch them together with matching yellow yarn. Thread a tapestry needle with a piece of yellow yarn and make six long single stitches all round the centre of the orange slice, positioning them as shown in the photograph. Finish off the thread invisibly in the middle of the slice.

PINEAPPLE SLICE

(make 2 pieces for each slice)

The texture of the stitches makes this piece particularly lifelike.

YOU ALSO WILL NEED

• Small quantities of DK-weight yarn in pale yellow, brown and ecru

ROW 1 using pale yellow yarn, ch 2, dc 1 in first ch st {1 dc sts}

ROW 2 ch 1, turn, dc 2 st in next st {2 dc sts}

ROW 3 ch 1, turn, dc 1, dc 2 st in next st {3 dc sts}

ROW 4 ch 1, turn, dc 2, dc 2 st in next st {4 dc sts}

ROW 5 ch 1, turn, dc 3, dc 2 st in next st {5 dc sts}

ROW 6 ch 1, turn, dc 4, dc 2 st in next st {6 dc sts}

ROW 7 ch 1, turn, dc 5, dc 2 st in next st {7 dc sts}

ROW 8 ch 1, turn, dc 6, dc 2 st in next st {8 dc sts}

ROW 9 ch 1, turn, dc 7, dc 2 st in next st {9 dc sts}

ROW 10 ch 1, turn, dc 8, dc 2 st in next st {10 dc sts}

ROW 11 ch 1, turn, dc 9, dc 2 st in next st {11 dc sts}

ROW 12 using brown yarn, ch 3, sl st 1 in chain, [dc 2, ch 1, sl st in front two loops of prev. dc] across, cast off

TO MAKE UP THE PINEAPPLE SLICE

When you have made the second piece, align the two pineapple pieces, right sides out, and whipstitch them together using matching yarn. Thread a tapestry needle with a length of ecru yarn and make three long stitches on the pineapple slice – check the photograph for placement. Finish off the yarn invisibly in the middle of the slice.

Pineapple Slice

Vegetable dip

A platter of crudités with a yarn bowl of creamy dip would make a great centrepiece to any buffet table. And there's a tempting selection here, from celery sticks and broccoli florets to piquant stuffed olives and juicy tomatoes. Altogether these represent the best nutrition that the wool world can offer.

INGREDIENTS
- 3.5 mm (US size E) crochet hook
- DK-weight yarn in the suggested colours (*each pattern calls for only a small amount of each colour of yarn*)
- Tapestry needle (*for weaving in yarn ends and sewing up side seams*)
- Scissors
- **Some pieces also need a little stuffing – choose a lightweight custom toy stuffing**

PATTERN TENSION
Using DK-weight yarn and a 3.5 mm (US size E) crochet hook, 5 dc x 5 rows = 2.5 cm x 2.5 cm (1" x 1")

Broccoli Floret

BROCCOLI FLORET
The broccoli and the cauliflower florets have the same pattern – you just need to change the colour that you use.

YOU ALSO WILL NEED
- Small quantities of DK-weight yarn in dark green and bright green
- A medium-sized sewing needle and green thread

MAIN BROCCOLI PIECE
RND 1 using dark green yarn, dc 6 in magic ring, sl st to close round {6 dc sts}

RND 2 ch 1, dc 1 in same space as prev. sl st, tr 3 in 1, [dc 2 in next st, tr 3 in next st] all round, sl st to close round {14 dc sts}

RND 3 ch 2, tr 2 in same space as prev. sl st, dc 2 in next st, dec 1 over 2, dc 1, [tr 3 in next st, dc 2 in next st, dec 1 over 2, dc 1] all round, sl st to close round {20 sts}

RND 4 ch 1, tr 1, dc 5, [dec 1 tr over 2 sts, dc 5] all round, sl st to close round {18 sts}

RND 5 switch to bright green yarn, ch 1, working in back loops only, dec 1st over 2, [dc 1, dec 1st over 2] all round, dc 1, sl st to close round {12 dc sts}

RND 6 ch 1, dec 1st over 2, [dc 1, dec 1st over 2] 3 times, dc 1, sl st to close round {8 dc sts}

RND 7 ch 1, dc all round, sl st to close round {8 dc sts}

RND 8 ch 1, dc all round, sl st to close round {8 dc sts}

RND 9 ch 1, dc all round, clean cast off {8 dc sts}

BROCCOLI BASE
RND 1 using bright green yarn, dc 6 in magic ring, clean cast off {6 dc sts}

TO MAKE UP THE BROCCOLI FLORET
Weave in and/or knot the loose yarn ends on the wrong side of work. Fill the main broccoli piece

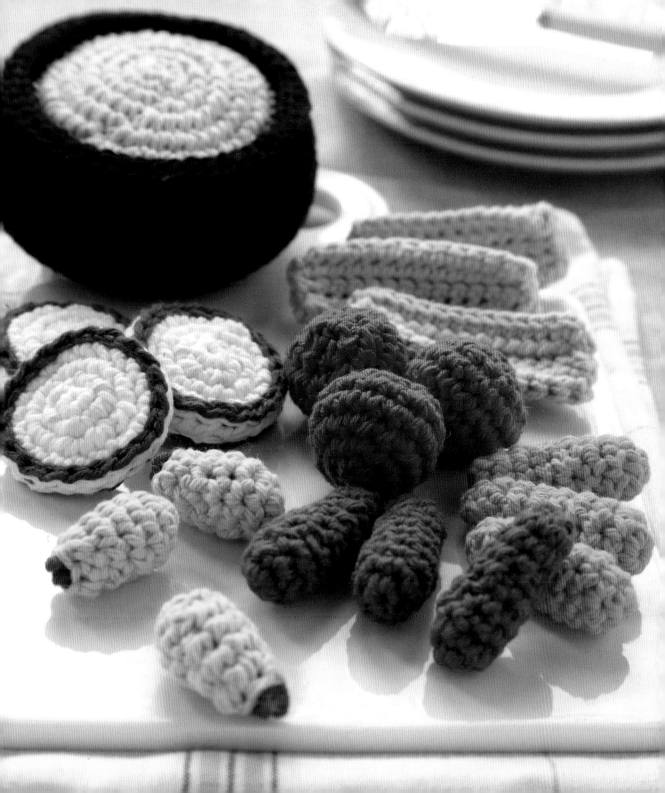

with stuffing, padding it so that it is firm but not too hard. Plug the open end with the broccoli base piece and stitch into place with the needle and thread.

CAULIFLOWER FLORET

The ecru and white mix makes for a subtly realistic cauliflower.

YOU ALSO WILL NEED
• Small quantities of DK-weight yarn in ecru and white
• Sewing needle and white thread

The cauliflower floret is worked in exactly the same way and with the same number of stitches as the broccoli floret, but using the ecru yarn instead of the dark green, and the white yarn instead of the bright green.

CARROT

Made from a solid little tube of crochet, with plenty of crunch!

YOU ALSO WILL NEED
• A small quantity of DK-weight yarn in bright orange

RND 1 dc 6 in magic ring, sl st to close round {6 dc sts}
RND 2 ch 1, [dc 2 in next st, dc 2], all round, sl st to close round {8 dc sts}
RND 3 ch 1, dc all round, sl st to close round {8 dc sts}
RND 4 ch 1, dc all round, sl st to close round {8 dc sts}
RND 5 ch 1, dc 3, dec 1 st over 2, dc 3, sl st to close round {7 dc sts}
RND 6 ch 1, dc all round, sl st to close round {7 dc sts}
RND 7 ch 1, dc all round, sl st to close round {7 dc sts}
RND 8 ch 1, dc all round, sl st to close round, cast off {7 dc sts}

TO MAKE UP THE CARROT
Fill it with a small amount of toy stuffing, thread a tapestry needle with orange yarn and stitch the end closed.

CORNICHON

No crudité selection would be complete without pickles.

YOU ALSO WILL NEED
• A small quantity of DK-weight yarn in dark green

The cornichon is worked in exactly the same way as the carrot, but using dark green yarn instead of bright orange.

CUCUMBER SLICE

(make 2 pieces for each slice)
A chain-stitch 'rind' adds the finishing touch to this piece.

YOU ALSO WILL NEED
• Small quantities of DK-weight yarn in white, dark green and yellow

RND 1 working in white yarn, dc 6 in magic ring, sl st to close round {6 dc sts}
RND 2 ch 1, dc 1 in same space as prev. sl st, [dc 2 in next st] all round, sl st to close round {11 dc sts}

Cauliflower Floret

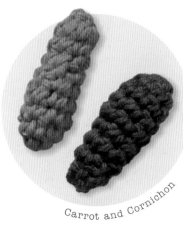

Carrot and Cornichon

RND 3 ch 1, dc 1 in same space as prev. sl st, dc 2 in next st, dc 1, [dc 2 in next st, dc 2 in next st, dc 1] all round, sl st to close round {19 dc sts}

RND 4 ch 1, dc all round, clean cast off {19 dc sts}

TO MAKE UP THE CUCUMBER SLICE

When you have made two pieces, weave in or knot the loose yarn ends on the wrong side of the crochet on both pieces. Thread a tapestry needle with dark green yarn and make a row of chain stitch all round the upper edge of each of the pieces. Rethread the needle with a piece of yellow yarn and make six short stitches radiating out from the centre of each piece to make the cucumber's 'seeds'.

TO FINISH OFF THE CUCUMBER SLICE

Align the two pieces, right sides out, and whipstitch together using white yarn.

STUFFED OLIVE

You could use taupe yarn if you prefer an anchovy-filled olive.

YOU ALSO WILL NEED

• A small quantity of DK-weight yarn in olive green and bright red

RND 1 using olive green yarn, dc 6 in magic ring, sl st to close round {6 dc sts}

RND 2 ch 1, inc in next st, [dc 1, inc in next st] all round, sl st to close round {8 dc sts}

RND 3 ch 1, dc all round, sl st to close round {8 dc sts}

RND 4 ch 1, dc all round, sl st to close round {8 dc sts}

RND 5 ch 1, dc all round, sl st to close round {8 dc sts}

RND 6 ch 1, dec 1 st over 2, [dc 1, dec 1 st over 2] all round, clean cast off {5 dc sts}

PIMENTO STUFFING FOR THE OLIVE

Using red yarn, ch 6, sl st 5, cast off. Make two pimento pieces and push the end with the loose yarn ends into the olive. Thread a tapestry needle with green yarn and securely stitch the pimento ends at the open end of the olive in place.

CHERRY TOMATO

A neat little globe tomato – just the right size for dipping.

YOU ALSO WILL NEED

• A small quantity of DK-weight yarn in bright red

RND 1 using bright red yarn, dc 6 in magic ring, continue all round in a spiral {6 dc sts}

RND 2 [dc 2 in next st] all round {12 dc sts}

RND 3 [dc 1, dc 2 in next st] all round {18 dc sts}

RND 4 dc all round {18 dc sts}

RND 5 dc all round {18 dc sts}

RND 6 [dc 1, dec 1 st over 2] all round {12 dc sts}

RND 7 [dec 1 st over 2] all round

TO MAKE UP THE TOMATO

Cast off the yarn, stuff the tomato with a small quantity of toy stuffing, then stitch up the open end using a tapestry needle and red yarn.

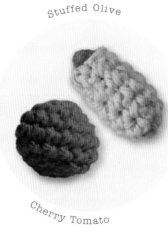

Cucumber Slice

Stuffed Olive

Cherry Tomato

CELERY STICK

Celery's natural central hollow makes it perfect for dipping.

YOU ALSO WILL NEED

• A small quantity of DK-weight yarn in bright green

ROW 1 using bright green yarn, ch 14, dc 13 {13 dc sts}

ROW 2 ch 1, turn, working in back loops only, dc 13 {13 dc sts}

ROW 3 ch 1, turn, working in front loops only, dc 13 {13 dc sts}

ROW 4 ch 1, turn, working in back loops only, dc 13 {13 dc sts}

ROW 5 ch 1, turn, working in back loops and the open front loops from the previous row, dc 13 {13 dc sts}

ROW 6 ch 1, turn, dc 13 {13 dc sts}

ROW 7 ch 1, turn, working through both loops of current row and open back loops from prev. row, dc 13 {13 dc sts}

ROW 8 ch 1, turn, dc 13 {13 dc sts}

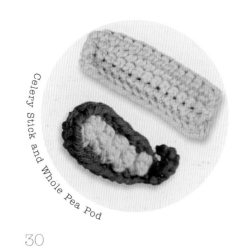

Celery Stick and Whole Pea Pod

ROW 9 ch 1, turn, working through both loops of current row and open front loops from prev. row, dc 13 {13 dc sts}

ROW 10 ch 1, turn, working through chain stitches of first row and both loops of current row, dc 13 (this should bind together the current and first rows), cast off {13 dc sts}

TO FINISH OFF THE CELERY STICK
Weave in the yarn's loose ends.

WHOLE PEA POD

Overlap the crochet 'bumps' to make the peas look realistic.

YOU ALSO WILL NEED

• A small quantity of DK-weight yarn in dark green and bright green
• A sewing needle and green thread

PEA POD
Using dark green yarn, ch 12, dc 1, tr 1, dtr 7, tr 1, dc 1, ch 2, continue all round to other side of the chain, dc 1, tr 1, dtr 7, tr 1, dc 1, ch 8, sl st 1 in chain, [miss 1, sl st 1 in next chain] 3 times, clean cast off.

PEAS
Using bright green yarn, ch 2, [dc 3, sl st 1 in next ch], [ch 3, {dc 3, sl st 1} in the 2nd loop from the hook] 4 times, cast off.

TO MAKE UP THE PEA POD
Fold the pod piece lengthways with the right side facing out, and weave in the loose yarn ends (the peas will fit into the groove). Weave in the loose yarn ends on the peas and arrange them in the pod with the wrong side up. Each 'bump' should overlap its neighbour a little. Sew the peas into place in the pod using the sewing needle and green thread.

BOWL OF DIP

This is made with a dip-filled inner lining in an outer casing.

YOU ALSO WILL NEED

• A small quantity of DK-weight yarn in off-white and black

DIP
RND 1 using off-white yarn, dc 6 in magic ring, sl st to close round {6 dc sts}

RND 2 ch 1, dc 1 in same space as prev. sl st, [dc 2 in next st] all round, sl st to close round {11 dc sts}

RND 3 ch 1, dc 2 in next st, dc 2 in next st, [dc 1, dc 2 in next st, dc 2 in next st] all round {19 dc sts}

RND 4 ch 1, dc 2 in next st, [dc 1, dc 2 in next st] all round, sl st to close round {29 dc sts}

RND 5 ch 1, dc 1, dc 2 in next st, [dc 2, dc 2 in next st] all round, sl st to close round {39 dc sts}

RND 6 ch 1, dc 2, dc 2 in next st, [dc 3, dc 2 in next st] all round, clean cast off {49 dc sts}

INNER BOWL

RND 1 using black yarn, dc 6 in magic ring, sl st to close round {6 dc sts}

RND 2 ch 1, dc 1 in same space as prev. sl st, [dc 2 in next st] all round, sl st to close round {11 dc sts}

RND 3 ch 1, dc 2 in next st, inc in next st, [dc 1, dc 2 in next st, dc 2 in next st] all round {19 dc sts}

RND 4 ch 1, dc 2 in next st, [dc 1, dc 2 in next st] all round, sl st to close round {29 dc sts}

RND 5 ch 1, dc 4, dc 2 in next st, [dc 5 dc 2 in next st] all round, sl st to close round {34 dc sts}

RND 6 ch 1, dc 5, dc 2 in next st, [dc 6, dc 2 in next st] all round, sl st to close round {39 dc sts}

RND 7 ch 1, dc 6, dc 2 in next st, [dc 7, dc 2 in next st] all round, sl st to close round {44 dc sts}

RND 8 ch 1, dc 7, dc 2 in next st, [dc 8, dc 2 in next st] all round, sl st to close round {49 dc sts}

RND 9 ch 1, dc all round, sl st to close round {49 dc sts}

RND 10 ch 1, dc all round, sl st to close round {49 dc sts}

RND 11 ch 1, dc all round, sl st to close round {49 dc sts}

RND 12 ch 1, dc all round, sl st to close round {49 dc sts}

RND 13 ch 1, dc all round, sl st to close round {49 dc sts}

RND 14 make sure that bowl is flipped inside-out; the surface of the right side of the bowl should be concave

Now attach the dip to the bowl. Using black yarn, hook through one stitch of the dip for each stitch in the row of the bowl – ch 1, dc all round, clean cast off. When you are halfway arround, fill the bowl shape with toy stuffing until it feels firm and 'full' before closing up the bowl completely.

Next, make the outer bowl.

OUTER BOWL

RND 1 using black yarn, dc 6 in magic ring, sl st to close round {6 dc sts}

RND 2 ch 1, dc 1 in same space as prev. sl st, [dc 2 in next st] all round, sl st to close round {11 dc sts}

RND 3 ch 1, dc 2 in next st, inc in next st, [dc 1, dc 2 in next st, dc 2 in next st] all round {19 dc sts}

RND 4 ch 1, dc 2 in next st, [dc 1, dc 2 in next st] all round, sl st to close round {29 dc sts}

RND 5 ch 1, dc 4, dc 2 in next st, [dc 5, dc 2 in next st] all round, sl st to close round {34 dc sts}

RND 6 ch 1, dc 5, dc 2 in next st, [dc 6, dc 2 in next st] all round, sl st to close round {39 dc sts}

RND 7 ch 1, dc 6, inc in next st, [dc 7, dc 2 in next st] all round, sl st to close round {44 dc sts}

RND 8 ch 1, dc 7, inc in next st, [dc 8, dc 2 in next st] all round, sl st to close round {49 dc sts}

RNDS 9–14 ch 1, dc all round, sl st to close round {49 dc sts}

RND 15 ch 1, dc all round, clean cast off {49 dc sts}

TO FINISH THE BOWL OF DIP
Nest the inner bowl in the outer. Thread a tapestry needle with black yarn and chain stitch all round the bowl's edge, catching the stitches of both the inner and the outer bowls and pulling them together neatly.

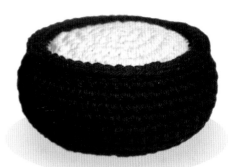

Bowl of Dip

31

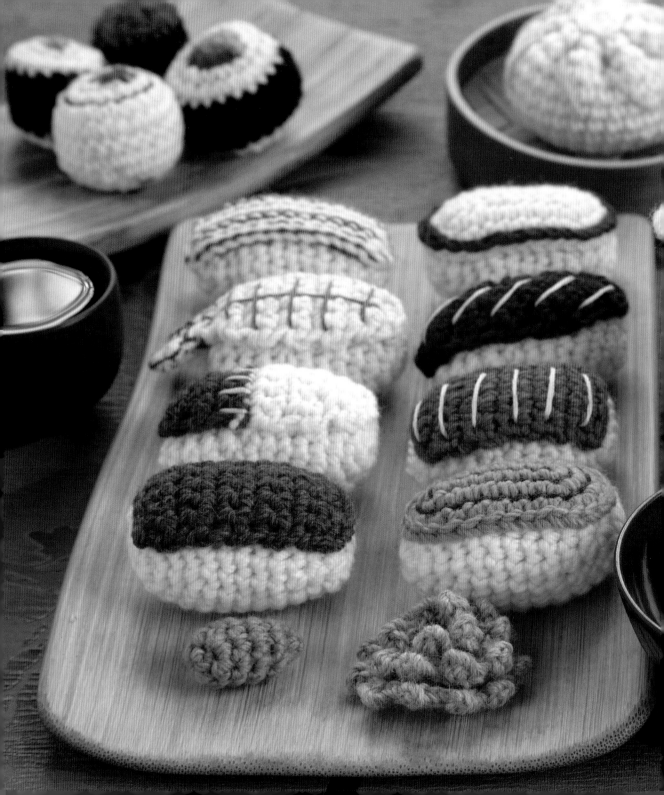

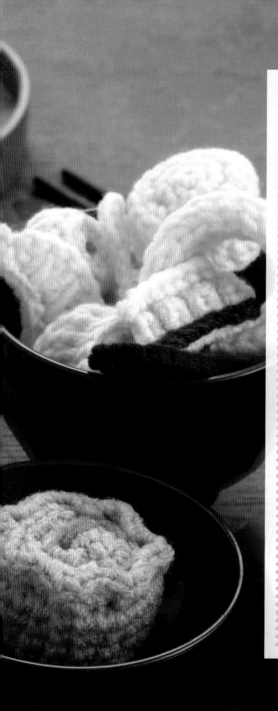

Menu
GLOBAL TREATS

SUSHI PLATTER
Nigiri (rice), with tuna, salmon, egg, octopus,
clam, crabstick, eel and prawn
Inside-out roll
Cucumber roll
Futomaki
Battleship roll
Pickled ginger
Wasabi

DIM SUM BASKET
Peach bun
Pork bun
Steamed bun
Siu mai
Sticky rice parcel
Spring onion pancake

STIR-FRY SELECTION
With courgette, onions, egg, prawn, beef
and chicken, scallop and beansprouts

Sushi platter

Everyone knows that sushi is good for you, and it's even better when you can custom-make yourself a special plateful of wool nigiri incorporating all of your favourite toppings. All the nigiri patterns here share the same simple rice base, but you can finish it with any of the eight options supplied.

INGREDIENTS
- 3.5 mm (US size E) crochet hook
- DK-weight yarn in the suggested colours (*each pattern calls for only a small amount of each colour of yarn*)
- Tapestry needle (*for weaving in yarn ends and sewing up seams*)
- Scissors
- **Some pieces need a little stuffing** – choose a lightweight custom toy stuffing

PATTERN TENSION
Using DK-weight yarn and a 3.5 mm (US size E) crochet hook, 5 dc x 5 rows = 2.5 cm x 2.5 cm (1" x 1")

NIGIRI RICE BASE
This makes the universal rice base for all the different toppings.

YOU ALSO WILL NEED
- A small quantity of DK-weight yarn in creamy white

ROW 1 ch 6, dc 4, dc 3 in next st, continue all round to other side of chain, dc 3, dc 2 in 1, sl st to close round {12 dc sts}

ROW 2 ch 1, dc 4, inc in next st, dc 5, inc in next st, dc 1, sl st to close round {14 sts}

ROW 3 ch 1, dc 4, inc in next st, dc 6, inc in next st, dc 2, sl st to close round {16 sts}

ROW 4 ch 1, dc 4, inc in next st, dc 7, inc in next st, dc 3, sl st to close round {18 sts}

ROWS 5–9 ch 1, dc all round, sl st to close round {18 sts}

ROW 10 ch 1, dc 8, dec 1 st over 2, dc 6, dec 1 st over 2, sl st to close round {16 sts}

ROW 11 dc 1, dc 7, dec 1 st over 2, dc 5, dec 1 st over 2 sl st to close round {14 sts}

ROW 12 ch 1, dc 6, dec 1 st over 2, dc 4, dec 1 st over 2, sl st to close round, cast off {12 sts}

TO MAKE UP THE NIGIRI BASE
Whipstitch the edges closed with matching yarn. Leave a small opening and fill with stuffing, then stitch the gap closed. Finish off the nigiri with the topping of your choice.

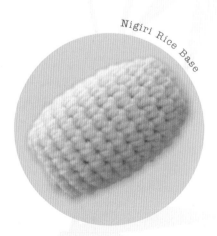

Nigiri Rice Base

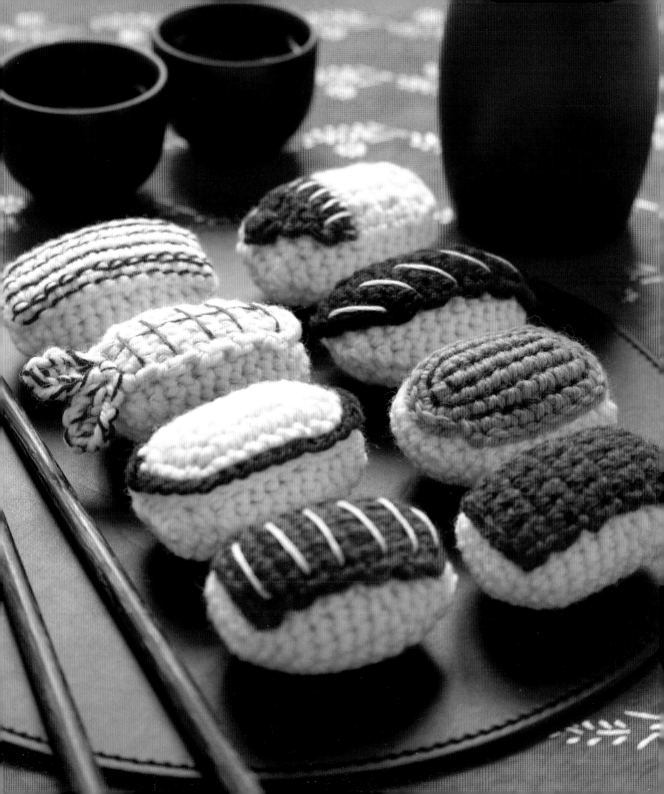

TUNA NIGIRI

An easy rectangle of crochet in the characteristic deep maroon-red of tuna makes this nigiri piece easy to recognize.

YOU ALSO WILL NEED
- A small quantity of DK-weight yarn in maroon
- Sewing needle and thread

ROW 1 ch 6, dc 5, turn {5 dc sts}
ROWS 2–11 ch 1, dc 5, turn {5 dc sts} Cast off and weave in yarn ends on the wrong side.

TO MAKE UP THE TUNA NIGIRI
Using a sewing needle and thread, carefully stitch the slice of tuna over the top of a nigiri rice base (see the photograph of the finished piece), taking care that the stitches do not show from the top.

SALMON NIGIRI

The stitches across the top of this nigiri imitate the streaks of fat.

YOU ALSO WILL NEED
- A small quantity of DK-weight yarn in deep orange
- Ecru six-strand embroidery floss (*you'll be using all six strands*)
- Embroidery needle
- Sewing needle and thread

Work the crochet piece in exactly the same way as for the tuna nigiri, but in the deep orange yarn. When you've finished the piece and woven in the yarn ends, thread an embroidery needle with a length of the ecru embroidery floss and make six long stitches at even intervals across the width of the salmon piece.

TO MAKE UP THE SALMON NIGIRI
Using a sewing thread and needle, carefully stitch the slice of salmon over the top of a nigiri rice base (see the photograph of the finished piece), taking care that the stitches do not show from the top.

EGG NIGIRI

The stitched spiral on the golden topping of this yarn nigiri imitates the rolled omelette that tops the edible type.

YOU ALSO WILL NEED
- A small quantity of DK-weight yarn in deep gold
- Brown six-strand embroidery floss (*you'll be using all six strands*)
- Embroidery needle
- Sewing needle and thread

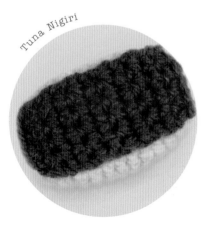

Tuna Nigiri

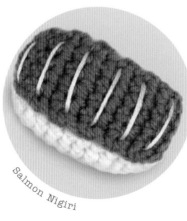

Salmon Nigiri

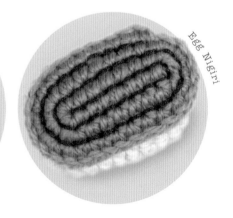

Egg Nigiri

Ch 9, dc 7, dc 3 in 1, continue around other side of chain, dc 6, dc 2 in 1 (continue around in a spiral), dc 7, [inc in next st] 3 times, dc 6, [inc in next st] 3 times, dc 7, [inc in next st] 3 times, dc 9, cast off.

When you've woven in the yarn ends, thread an embroidery needle with a length of the brown embroidery floss and sew a spiral between the stitches, using backstitch and checking the photograph of the finished piece to make sure of the placement.

TO MAKE UP THE EGG NIGIRI
Using a sewing needle and thread, carefully stitch the crocheted egg piece over the top of a nigiri rice base (see the photograph of the finished piece), taking care that the stitches do not show from the top.

OCTOPUS NIGIRI

A deep-purple ring all round the creamy white centre identifies this sushi as octopus. Like the equally simple tuna nigiri, it works well in a platter of mixed toppings.

YOU ALSO WILL NEED
• Small quantities of DK-weight yarn in creamy white and deep purple
• Sewing needle and thread

Using the creamy white yarn, work the crochet piece in exactly the same way as for the egg topper (left), but do not cast off.

Now switch to deep purple yarn and dc 1, sl st 17, [ch 1, dc 1, ch 1, sl st 1] 5 times. Cast off cleanly and weave in the end.

TO MAKE UP THE OCTOPUS NIGIRI
Using a sewing needle and thread, carefully stitch the completed octopus piece over the top of a nigiri rice base (see the photograph of the finished piece), taking care that the stitches do not show from the top.

CLAM NIGIRI

You can spot a clam nigiri by the mix of brown and white shellfish meat resting on its top. A bi-coloured topper finished off with a few embroidered stitches recreates the effect.

YOU ALSO WILL NEED
• Small quantities of DK-weight yarn in creamy white and maroon
• Ecru six-strand embroidery floss (*you'll be using all six strands*)
• Embroidery needle
• Sewing needle and thread

ROW 1 working with creamy white yarn, ch 4, dc 3, turn {3 dc sts}
ROW 2 ch 1, dc 1, inc in next st, dc 1, turn {4 dc sts}
ROW 3 ch 1, dc 1, inc in next st, inc in next st, dc 1, turn {6 dc sts}

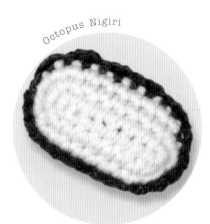

Octopus Nigiri

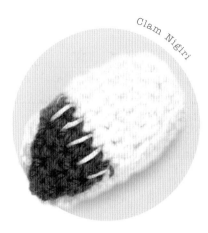

Clam Nigiri

ROWS 4–7 ch 1, dc across, turn {6 dc sts}

ROW 8 switch to maroon yarn, ch 1, dc across, turn {6 dc sts}

ROW 9 ch 1, miss 1, dc across, turn {5 dc sts}

ROW 10 ch 1, dc 3, miss 1, dc 1 turn {4 dc sts}

ROW 11 ch 1, miss 1, dc 3, turn {3 dc sts}

ROW 12 ch 1, dc 1, miss 1, dc 1, turn {2 dc sts}

ROW 13 ch 1, miss 1, dc 1 {1 dc sts}, cast off

When you've completed the crochet, thread an embroidery needle with a length of the ecru embroidery floss and make six long single stitches from the maroon part of the crochet to where the maroon and creamy white yarns meet. Check the photograph of the finished piece for placement.

TO MAKE UP THE CLAM NIGIRI
Using a sewing thread and needle, carefully stitch the slice of clam over the top of a nigiri rice base (see the photograph of the finished piece), taking care that the stitches do not show from the top.

CRABSTICK NIGIRI

The delicate red lines are made from rows of neat backstitch and chain stitch.

YOU ALSO WILL NEED
- A small quantity of DK-weight yarn in creamy white
- Red six-strand embroidery floss (*you'll be using all six strands*)
- Embroidery needle
- Sewing needle and thread

ROW 1 ch 15, dc 14, turn {14 dc sts}
ROWS 2–4 ch 1, dc 14, turn {14 dc sts}, cast off

When you've completed the crochet, thread an embroidery needle with a length of the red embroidery floss. Make four rows of backstitch and two of chain stitch along the length of the crochet piece, checking with the photograph of the finished nigiri for placement. Pull the loops of the chain stitch carefully so that they make little looped shapes rather than pulling tight into lines.

TO MAKE UP THE CRABSTICK NIGIRI
Using a sewing needle and thread, stitch the crabstick piece over the top of a nigiri rice base (see the photograph of the finished piece), taking care that the stitches do not show from the top.

EEL NIGIRI

The rich smokiness of the eel is denoted in dark-brown yarn to represent the seafood with creamy stitched 'veining', and a stitched black edge.

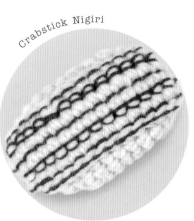

Crabstick Nigiri

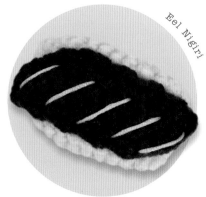

Eel Nigiri

YOU ALSO WILL NEED
- A small quantity of DK-weight yarn in dark brown
- White and black six-strand embroidery floss (*you'll be using all six strands*)
- Embroidery needle

ROW 1 ch 8, dc 1 in third loop from hook, dc 5, turn {6 dc sts}

ROWS 2, 4, 6, 8 ch 1, inc in next st, dc 3, miss 1, dc 1, turn {6 dc sts}

ROWS 3, 5, 7, 9 ch 1, miss 1, dc 4, inc in next st, turn {6 dc sts}, cast off

When you've completed the crochet, thread an embroidery needle with a length of the black embroidery floss and make a line in running stitch all round the edge of the eel topping, about one stitch in from the edge. Re-thread the needle with the ecru floss and make five large, single diagonal stitches across the width of the crochet piece, checking with the photograph to place them correctly.

TO MAKE UP THE EEL NIGIRI
Using a sewing needle and thread, stitch the eel piece over the top of a nigiri rice base (see photograph of the finished piece), taking care that the stitches do not show from the top.

PRAWN NIGIRI

The prawn piece is given its pink and white flesh by crocheting yarn and embroidery floss together. Unwind a good length of floss before you start, so that it doesn't pull as you crochet the stitches.

YOU ALSO WILL NEED
- A small quantity of DK-weight yarn in creamy white
- Pink, deep pink and red six-strand embroidery floss (*you'll be using all six strands*)
- Embroidery needle
- Sewing needle and thread

Holding a strand of creamy white yarn and a piece of pink embroidery floss together, work as follows.

ROW 1 ch 4, dc 3, turn {3 dc sts}

ROW 2 ch 1, dc 2, inc in next st, turn {4 dc sts}

ROW 3 ch 1, dc 3, inc in next st, turn {5 dc sts}

ROWS 4–9 ch 1, dc 5, turn {5 dc sts}

ROW 10 ch 1, miss 1, dc 4, turn {4 dc sts}

ROW 11 ch 1, miss 1, dc 3, turn {3 dc sts} (after this point, replace the strand of pink embroidery floss with the red embroidery floss)

ROW 12 ch 1, miss 1, dc 2, turn {2 dc sts}

ROW 13 ch 4, work 1 dtr leaving the last two loops on the hook. Work 1 dtr in same st, pulling last loop through all of the loops on the hook, ch 1, cast off. Join again in next dc, ch 4, work 1 dtr leaving the last two loops on the hook. Work 1 dtr in same st, pulling last loop through all of the loops on the hook, ch 1, cast off.

When you've completed the crochet, thread an embroidery needle with a length of the deep pink floss and make one long stitch, the full length of the prawn 'body', ending at the tail. Overlay this with five pairs of stitches at right angles (check the photograph of the finished piece for placement).

TO MAKE UP THE PRAWN NIGIRI
Using a sewing needle and thread, stitch the prawn over the top of a nigiri rice base (see the photograph of the finished piece), taking care that the stitches do not show from the top.

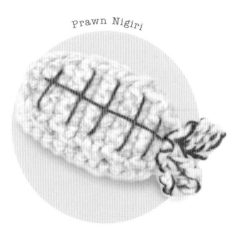

Prawn Nigiri

OTHER SUSHI OPTIONS

Of course, popular and varied
though they are, nigiri sushi
aren't the only options. Here is
a selection of rolled maki and
uromaki sushi for the enthusiast
– without, of course, forgetting
the necessary accompaniments
of hot wasabi and pickled ginger.

INSIDE-OUT ROLL

(make 2 pieces for each roll)
So-called because the rice is on
the outside and the nori layer
inside the roll, the inside-out roll
takes a good deal of expertise
to make – unless it's in crochet,
of course!

YOU ALSO WILL NEED

- Small quantities of DK-weight
 yarn in mid-green and
 creamy white
- Short lengths of dark orange and
 dark green DK-weight yarn
- Black six-strand embroidery floss
 (you'll be using all six strands)
- Embroidery needle

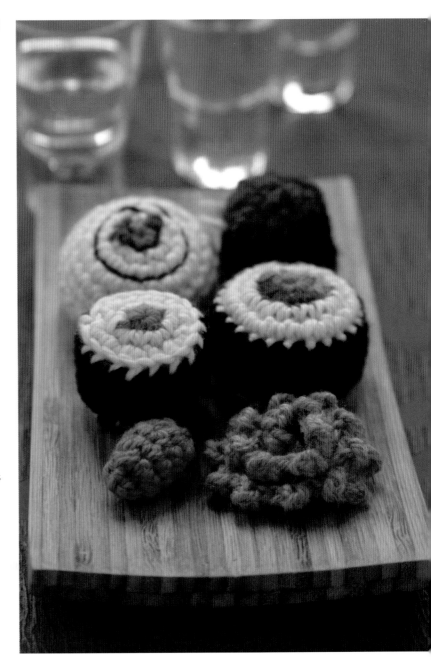

ROW 1 working in mid-green yarn, dc 6 in magic ring, clean colour change sl st using creamy white yarn to close the round {6 dc sts}

ROW 2 using creamy white yarn, ch 1, dc 1 in same place as ch, [inc in next st] all round, sl st to close round {11 dc sts}

ROW 3 ch 1, inc in next st, [dc 1, inc in next st] all round, sl st to close round {17 dc sts}

ROW 4 ch 1, dc 1, inc in next st, [dc 2, inc in next st] all round, sl st to close round {23 dc sts}

ROW 5 ch 1, dc all round, sl st to close round {23 dc sts}

ROW 6 ch 1, dc all round, clean cast off {23 dc sts}

NOTE When making second piece, leave out Row 5 and continue directly into Row 6.

Weave in and/or knot loose yarn ends on the wrong side of the crochet.

Thread an embroidery needle with black embroidery floss and add the nori layer with a ring of backstitch (check the photograph of the finished piece for placement). Thread a yarn needle with the dark orange yarn and make French knots for the filling, then repeat with the dark green yarn. Backstitch all round the knots with black yarn to add an extra line of nori detailing.

TO MAKE UP THE INSIDE-OUT ROLL
Place the two pieces of crochet together and whipstitch them at the edges with the creamy white yarn, leaving a small opening. Fill loosely with toy stuffing before stitching the gap closed.

CUCUMBER ROLL

(make 2 pieces for each roll)
A refreshing column of cucumber nestles in the middle of a cylinder of rice, itself rolled in a thin layer of nori to hold it together.

YOU ALSO WILL NEED

- Small quantities of DK-weight yarn in mid-green, creamy white and black

ROW 1 working in green yarn, dc 6 in magic ring, clean colour change, sl st using creamy white yarn to close the round {6 dc sts}

ROW 2 working in creamy white yarn, ch 1, dc 1 in same place as ch, [inc in next st] all round, sl st to close round {11 dc sts}

ROW 3 ch 1, inc in next st, [dc 1, inc in next st] all round, clean colour change sl st using black yarn to close the round {17 dc sts}

ROW 4 working in black yarn, ch 1, dc all round, sl st to close round {17 dc sts}

ROW 5 ch 1, dc all round, sl st to close round, clean cast off {17 dc sts}

Weave in the loose yarn ends on the wrong side of the crochet.

TO MAKE UP THE CUCUMBER ROLL
When you have made the second piece, align the two pieces of crochet and whipstitch them at the edges with black yarn, leaving a small opening unstitched. Fill loosely with toy stuffing before stitching the gap closed.

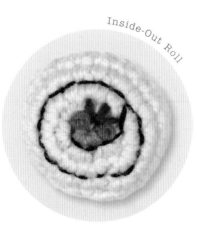

Inside-Out Roll

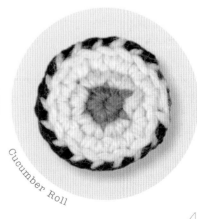

Cucumber Roll

41

FUTOMAKI

(make 2 pieces for each roll)

These plump maki can incorporate a whole range of fillings. Our version includes both cucumber and chopped tuna.

YOU ALSO WILL NEED

• Small quantities of DK-weight yarn in mid-green, creamy white, black, heather pink, and maroon

ROW 1 working with mid-green yarn, dc 6 in magic ring, clean colour change sl st using heather pink yarn to close the round {6 dc sts}

ROW 2 working with heather pink yarn, ch 1, dc 1 in same, [inc in next st] twice, switch to maroon yarn, [inc in next st] 3 times, clean colour change sl st using creamy white yarn to close round {11 dc sts}

ROW 3 working with creamy white yarn, ch 1, inc in next st, [dc 1, inc in next st] all round, sl st to close round {17 dc sts}

ROW 4 ch 1, dc 1, inc in next st, [dc 2, inc in next st] all round, clean colour change sl st using black yarn to close round {23 dc sts}

ROW 5 using black yarn, ch 1, dc all round, sl st to close round {23 dc sts}

ROW 6 ch 1, dc all round, clean cast off {23 dc sts}

NOTE When making the second piece, leave out Row 5 and continue directly into Row 6.

Weave in and/or knot loose yarn ends on the 'wrong' side of the crochet.

TO MAKE UP THE FUTOMAKI
Place the two pieces of crochet together and whipstitch them all round the edges with black yarn, leaving a small opening. Fill loosely with toy stuffing before stitching the gap closed.

BATTLESHIP ROLL

(make 2 pieces, 1 top and 1 bottom piece, for each roll)

So-called because this sushi roll supposedly looks like the prow of a battleship, it consists of nori strips forming a 'cup' for less solid ingredients, such as the fish roe here.

YOU ALSO WILL NEED

• Small quantities of DK-weight yarn in dark orange, creamy white, and black
• 2.5-cm (1-in) square of bright green felt
• Sewing needle and green thread

TOP PIECE

ROW 1 working with dark orange yarn, dc 6 in magic ring, sl st to close round {6 dc sts}

ROW 2 ch 1, tr in same place, [dc 1, tr 1 in same place] all round, sl st to close round {11 sts}

ROW 3 ch 1, tr in same place, [dc 1, tr 1 in same place] twice, dc 3, [dc 1, tr 1 in same place] 3 times, dc 3, clean colour change sl st, using black yarn to close round {17 sts}

ROW 4 working with black yarn, ch 1, dc all round, sl st to close round {17 sts}

ROW 5 ch 1, dc all round, clean cast off {17 sts}

Futomaki

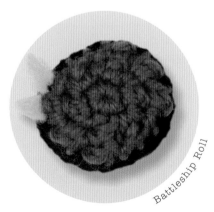

Battleship Roll

BOTTOM PIECE

ROW 1 working with creamy white yarn, dc 6 in magic ring, sl st to close round {6 dc sts}

ROW 2 ch 1, dc in same place, [inc in next st] all round, sl st to close round {11 dc sts}

ROW 3 ch 1, dc in same place, [inc in next st] twice, dc 3, [inc in next st] 3 times, clean colour change sl st using black yarn to close round {17 dc sts}

ROW 4 working with black yarn, ch 1, dc all round, sl st to close round {17 dc sts}

ROW 5 ch 1, dc all round, clean cast off {17 dc sts}

Weave in loose yarn ends on the wrong side of the crochet.

TO MAKE UP THE BATTLESHIP ROLL

Place the top and bottom pieces of crochet together and whipstitch them along the edge with black yarn, leaving a small opening. Fill loosely with toy stuffing before stitching the gap closed. Cut 2 green felt triangles, each 2 cm (¾ in) long and 1 cm (⅜ in) wide. Using the blunt end of a needle, carefully push the wide end of each triangle into the top edge of the roll just under the orange topping (check the photograph of the finished piece for placement). Using a sewing needle and green thread, sew the pieces in place, making small stitches that don't show.

PICKLED GINGER

The pickled ginger for the sushi platter is crocheted as a long piece and then stitched together into a neat spiral.

YOU ALSO WILL NEED

- A small quantity of DK-weight yarn in heather pink

Ch 24, tr 2 in third loop from hook, ch 2, sl st in front two loops of prev. tr*, [tr 2 in next ch, ch 2, sl st in front two loops of prev. tr] continue from * back to end of chain, cast off.

TO MAKE UP THE PICKLED GINGER

Thread a tapestry needle with matching yarn and curl the crocheted strip into a spiral, checking the photograph of the finished piece to shape it correctly. Use the needle and yarn to stitch the spiral together, using small stitches on the underside of the spiral, then cast off the yarn.

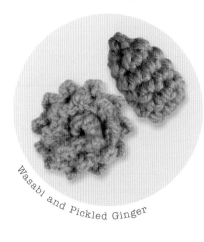

Wasabi and Pickled Ginger

WASABI

No sushi meal would be complete without a dab of the fiery hot Japanese horseradish called wasabi.

YOU ALSO WILL NEED

- A small quantity of DK-weight yarn in olive green
- Oddments of yarn in the same colour for stuffing (this piece is so small that you will find it easier to fill it with odds and ends of yarn than to use custom-made toy stuffing)

ROW 1 ch 3, dc 1, dc 3 in next st, continue all round to other side of chain, dc 2 in next st, sl st to close round {6 dc sts}

ROW 2 ch 1, dc 1, inc in next st, dc 3, inc in next st, sl st to close round {8 dc sts}

ROW 3 ch 1, dc all round, sl st to close round {8 dc sts}

ROW 4 ch 1, dc all round, sl st to close round {8 dc sts}

ROW 5 ch 1, dc 1, dec 1 st over 2, dc 2, dec 1 st over 2, dc 1, sl st to close round, cast off {6 dc sts}

TO MAKE UP THE WASABI

Stuff with the yarn oddments and stitch the end closed, using a tapestry needle threaded with matching yarn.

Dim sum basket

Dim sum dishes are a firm favourite among the world's snack foods and the range here covers most people's first picks – you'll find peach and pork buns, and tasty siu mai, as well as a spring onion pancake and sticky rice to finish off your Far Eastern feast. Of course they're all made of wool but gathered together in their steaming basket, they can look unnervingly realistic!

INGREDIENTS

- 3.5 mm (US size E) crochet hook
- DK-weight yarn in the suggested colours (*each pattern calls for only a small amount of each colour of yarn*)
- Tapestry needle (*for weaving in yarn ends and sewing up seams*)
- Scissors
- **Some pieces need a little stuffing – choose a lightweight custom toy stuffing**

PATTERN TENSION
Using DK-weight yarn and a 3.5 mm (US size E) crochet hook, 5-6 dc x 5-6 rows = 2.5 cm x 2.5 cm (1" x 1")

PEACH BUN

This yarn version has all the plump appeal of the real thing. An authentic blush has been added by felting a little wool roving over the top of the bun.

YOU ALSO WILL NEED

- A small quantity of DK-weight yarn in cream and dark green
- A small amount of pink wool roving (*see notes in pattern*)
- Felting needle
- Pink six-strand embroidery floss (*you'll be using all six strands*)
- Embroidery needle
- Sewing needle and thread

RND 1 using cream yarn, dc 6 in magic ring, continue all round in a spiral {6 dc sts}

RND 2 [inc in next st] all round {12 dc sts}

RND 3 [dc 1, inc in next st] all round {18 dc sts}

RND 4 [dc 2, inc in next st] all round {24 dc sts}

RND 5 [dc 3, inc in next st] all round {30 dc sts}

RND 6 [dc 4, inc in next st] all round {33 dc sts}

RND 7 dc all round {33 dc sts}

RND 8 dc all round {33 dc sts}

RND 9 [dc 4, dec 1 st over 2] all round {30 dc sts}

RND 10 [dc 3, dec 1 st over 2] all round {24 dc sts}

RND 11 [dc 2, dec 1 st over 2] all round {18 dc sts}

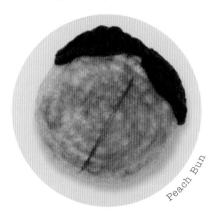

Peach Bun

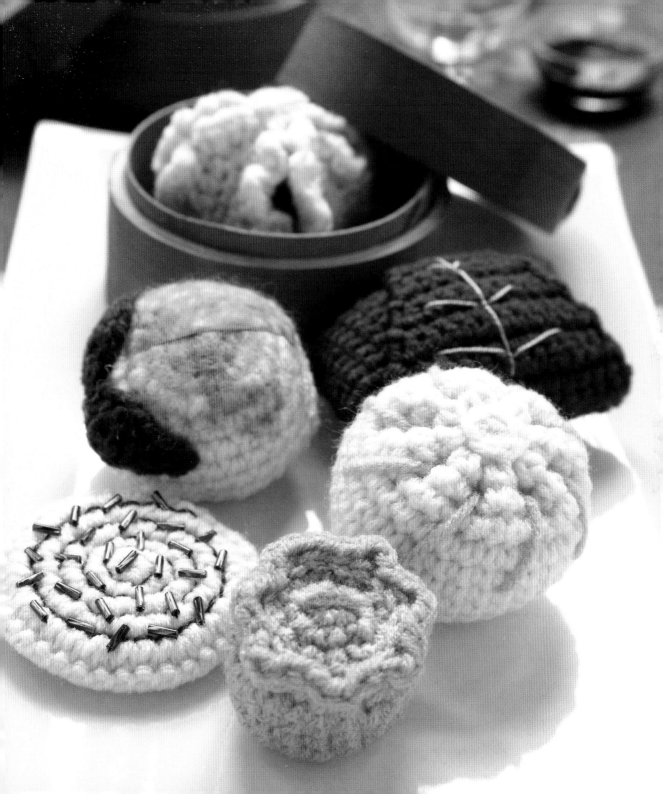

RND 12 [dc 1, dec 1st over 2] all round {12 dc sts}

RND 13 fill with stuffing before fully closing, [dec 1st over 2] all round, cast off, stitch closed {6 dc sts}

LEAF

Using dark green yarn, (ch 8, sl st 1, dc 1, tr 1, dtr 2, tr 1, sl st 1) twice, cast off.

TO MAKE UP THE PEACH BUN

Make the pink shading on top of the bun by taking a small piece of pink roving and rolling it into a sphere about the size of a grape. Roving is raw wool used in felting projects, and this piece is going to be stretched very thin and felted onto the top of the bun using a felting needle, which has tiny sharp barbs at the end and which will 'knit' the roving fibres into the crocheted surface. When you have pulled the small ball of roving into a very thin layer, felt it onto the bun top by repeatedly pushing the felting needle through the roving layer and into the crochet. You'll find that the roving will become woven in with the yarn fibres until it is firmly attached to the bun.

Take an embroidery needle and thread it with the pink floss, then make one long single stitch across the top centre of the bun. Bring the needle out a little way away from the stitch end and pull the floss until the tightened stitch makes a slight indentation on the bun top. Knot the floss to hold the indentation in place, and hide the knot inside the bun. Finally, stitch the leaf into place using a sewing needle and thread.

PORK BUN

The crinkled edges act as an immediate identifier for the steamed pork bun, which contains plenty of juicy yarn filling. The filling and the wrapper are crocheted separately and then sewn together to make up the whole piece.

YOU ALSO WILL NEED
- Small quantities of DK-weight yarn in cream and claret-red
- Sewing needle and thread

RND 1 using cream yarn, dc 8 in magic ring, sl st to close round {8 dc sts}

RND 2 ch 1, dc 1 in same space as prev. sl st, [inc in next st] all round, sl st to close round {15 dc sts}

RND 3 ch 1, dc 1 in same space as prev. sl st, inc in next st, dc 2, [inc in next st, inc in next st, dc 2] all round, sl st to close round {23 dc sts}

RND 4 ch 1, dc 1 in same space as prev. sl st, inc in next st, dc 4, [inc in next st, inc in next st, dc 4] all round, sl st to close round {31 dc sts}

RND 5 ch 1, dc all round, clean cast off {31 dc sts}

RND 6 join again in the fourth loop after the prev. clean cast off, ch 4, dc 3, clean cast off in the space after the join {3 dc sts}

RND 7 join two sts away from the prev. join. tr 2, htr 1, [htr 2 in next st, ch 1, htr 2 in next st], htr 1, tr 2, clean cast off two sts away from the prev. clean cast off {10 dc sts}

RND 8 join in stitch before the prev. join, [{dc 1, ch 1, dc 1, ch 1} in next st] all round, clean cast off in stitch after prev. clean cast off {22 dc sts}

Repeat Rounds 6 through 8 three more times, starting each time in 4th loop from prev., cast off.

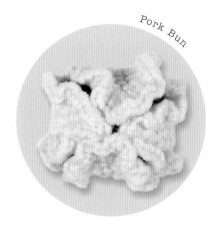

Pork Bun

PORK FILLING

RND 1 using red claret yarn, dc 6 in magic ring, continue around in a spiral {6 dc sts}

RND 2 [inc] all round {12 dc sts}

RND 3 [dc 1, inc] all round {18 dc sts}

RND 4 [dc 2, inc] all round {24 dc sts}

RND 5 [dc 3, inc] all round {30 dc sts}

RND 6 dc all round {30 dc sts}

RND 7 dc 1, miss 1, sl st 1, clean cast off

TO MAKE UP THE PORK BUN Start with the wrapper piece right side down and the filling piece right side up. Using a sewing needle and thread, stitch round the edges of the filling, sewing it to the centre of the bun. Before you have stitched all the way around, fill with a small amount of toy stuffing. Then pull the edges of the wrapper piece up over the filling and sew them into place with small stitches. Finish off the thread inside the bun.

STEAMED BUN

You can almost see the steam rising from the surface of this dumpling. You could serve four together and see if anyone spots that they're not actually edible!

YOU ALSO WILL NEED

- Small quantities of DK-weight yarn in cream and buff
- Sewing needle and thread

RND 1 using cream yarn, Dc 6 in magic ring, continue all round in a spiral {6 dc sts}

RND 2 [inc in next st] all round {12 dc sts}

RND 3 [dc 1, inc in next st] all round {18 dc sts}

RND 4 [dc 2, inc in next st] all round {24 dc sts}

RND 5 [dc 3, inc in next st] all round {30 dc sts}

RND 6 [dc 4, inc in next st] all round {33 dc sts}

RNDS 7–12 dc all round {33 dc sts}

RND 13 dc all round miss 1, sl st {33 dc sts}, clean cast off

TOP

Using cream yarn, dc 6 in magic ring, clean cast off.

TO MAKE UP THE STEAMED BUN Thread a tapestry needle with cream yarn and run it through the top of every other stitch on the edge of the main bun piece, then fill the bun with stuffing, pull the yarn tight and knot the ends. Use the sewing needle and thread to stitch the top piece onto the gathered opening of the bun. Thread a tapestry needle with a piece of the buff-coloured yarn and stitch large, loose single stitches between the gathers (look at the photograph of the finished piece to check the placement of these). Each stitch should be 4 rows tall and about 4 sts apart at the bottom. Use the sewing needle and thread to sew down the centre of each stitch invisibly so that it sits neatly in position. Fasten the sewing thread off inside the bun.

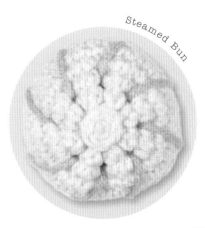

Steamed Bun

SIU MAI

The filling of siu mai (Chinese dumplings served in dim sum) can consist of many different ingredients. The stuffing for our version consists of, among other things, chopped prawns, pork and mushrooms. They are all made of wool, of course, and finished with a dot of roe in the centre.

YOU ALSO WILL NEED
• Small quantities of DK-weight yarn in gold, buff and deep orange
• Sewing needle and thread

BODY PIECE

RND 1 using gold yarn, dc 6 in magic ring, sl st to close round {6 dc sts}

RND 2 ch 1, dc 1 in same space as prev. sl st, [inc in next st] all round, sl st to close round {11 dc sts}

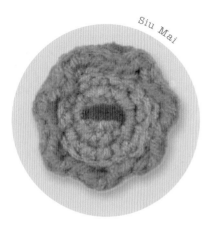

Siu Mai

RND 3 ch 1, dc 1 in same space as prev. sl st, dc 1, [inc in next st, dc 1] sl st to close round {17 dc sts}

RND 4 (working in back loops only) ch 1, dc all round, sl st to close round {17 dc sts}

RND 5 ch 1, dc all round, sl st to close round {17 dc sts}

RND 6 ch 1, dc 1 in same space as prev. sl st, dc 2, [inc in next st, dc 2] all round, sl st to close round {23 dc sts}

RND 7 ch 1, dc all round, sl st to close round {23 dc sts}

RND 8 ch 1, dc 1 in same space as prev. sl st, dc 3, [inc in next st, dc 3] all round, clean cast off {29 dc sts}

TOP PIECE

RND 1 using buff yarn, dc 6 in magic ring, sl st to close round {6 dc sts}

RND 2 ch 1, dc 1 in same space as prev. sl st, [inc in next st] all round, sl st to close round {11 dc sts}

RND 3 ch 1, dc 1 in same space as prev. sl st, dc 1, [inc in next st, dc 1] all round, clean cast off {17 dc sts}

TO MAKE UP THE SIU MAI
Thread a tapestry needle with gold yarn and make a running stitch all round the edge of the main piece, making each stitch about 2 dc wide. Pull yarn tight to gather the rim until it is the right size for the top piece to fit snugly inside it. Knot the yarn and weave in the ends.

Rethread the tapestry needle with the deep orange yarn and make two stitches across the centre of the top – each stitch should be as long as Round 1 is wide.

Using a sewing needle and thread, stitch the top into place, fitting it neatly into the rim of the main piece. Leave a gap and fill with a small amount of stuffing before stitching completely closed.

STICKY RICE PARCEL

The dark green of the lotus leaf around this parcel is set off by the lighter green of the stitched vein details in the centre.

YOU ALSO WILL NEED
• A small quantity of DK-weight yarn in dark green
• Bright green six-strand embroidery floss
• Embroidery needle

RND 1 using dark green yarn, ch 16, dc 14, dc 3 in next st, continue all round to other side of chain, dc 14, continue all round in a spiral {31 dc sts}

RND 2 dc 2 in next st, dc to end of side, dc 2 in next st down other side, dc to end {33 dc sts}

RNDS 3–9 dc all round {33 dc sts}

RND 10 dc 9, dec 1st over 2, dc 15, dec 1st over 2, dc 5 {31 dc sts}

RND II dc 8 {8 dc sts}

RND 12 ch I, turn, fold round together with the ch I on the fold and work each following stitch through both layers dc 15 (fill your parcel with stuffing before completing row) {15 dc sts}

RNDS 13–25 ch I, turn, miss I, dc across {14 to 2}, cast off.

TO MAKE UP THE STICKY RICE PARCEL
Separate out a four-strand length of the bright green floss and thread the embroidery needle with it. Stitch a row of backstitch down the centre of the open flap to its point, then stitch three pairs of veins off this central line (check the photograph for placement). Finish off on the wrong side of the flap, then thread a tapestry needle with the dark green yarn and whipstitch the flap to the main body of the sticky rice parcel.

SPRING ONION PANCAKE

(make 2 pieces for each pancake)
This makes a cute, glittery piece for the dim sum steaming basket – the tiny spring onion pieces are made from glittery green bugle beads.

YOU ALSO WILL NEED
- A small quantity of DK-weight yarn in cream
- Dark brown six-strand embroidery floss
- Embroidery needle
- Green glass bugle beads (*approximately 60*)
- Beading needle

RND I using cream yarn, dc 6 in magic ring, continue all round in a spiral {6 dc sts}

RND 2 [inc in next st] all round {12 dc sts}

RND 3 [dc I, inc in next st, inc in next st] all round {20 dc sts}

RND 4 [dc I, inc in next st] all round {30 dc sts}

RND 5 [dc 2, inc in next st] all round {40 dc sts}

RND 6 dc I, miss I, sl st, clean cast off

TO MAKE UP THE SPRING ONION PANCAKE
Thread up an embroidery needle with a piece of the dark brown floss (use a thickness of all six strands) and make a line of backstitch between the crochet rows of one of the spiral pieces (check the photograph of the finished piece for placement). Thread a beading needle (this is a needle with an especially small head so that beads will slip over it easily) with a single strand of the brown floss and stitch about 30 bugle beads at scattered, random angles around the stitched spiral. Repeat both the backstitch and the beading on the second pancake piece.

Thread a tapestry needle with the cream yarn and, right sides out, whipstitch the two pieces together, sewing the yarn end in invisibly between the two.

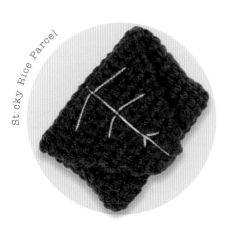
Sticky Rice Parcel

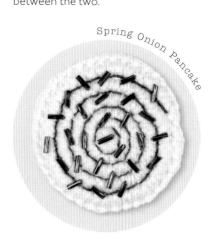
Spring Onion Pancake

Stir-fry selection

Not only do these patterns offer you a range of ingredients for a delicious stir-fry, but you've got the means to season the dish as well. Whether you favour meat, seafood or even egg added to a delicious vegetable mix, you'll find everything you could want in the following recipes.

INGREDIENTS
- 3.5 mm (US size E) crochet hook
- DK-weight yarn in the suggested colours (*each pattern calls for only a small amount of each colour of yarn*)
- Tapestry needle (*for weaving in yarn ends and sewing up seams*)
- Scissors
- Some pieces need a little stuffing – choose a lightweight custom toy stuffing

PATTERN TENSION
Using DK-weight yarn and a 3.5 mm (US size E) crochet hook, 5–6 dc x 5–6 rows = 2.5 cm x 2.5 cm (1" x 1")

SAUCE BOTTLE
Whether you like soy sauce or oyster sauce, you'll need a bottle to dispense it from.

YOU ALSO WILL NEED
- Small quantities of DK-weight yarn in cream and buff

BASE
RND 1 Using buff yarn, dc 6 in magic ring, sl st to close round {6 dc sts}

RND 2 ch 1, dc 1 in same space as prev. sl st, [inc in next st] all round, sl st to close round {11 dc sts}

RND 3 ch 1, dc 1 in same space as prev. sl st, dc 1, [inc in next st, dc 1] all round, sl st to close round {17 dc sts}

RND 4 ch 1, dc 1 in same space as prev. sl st, dc 2, [inc in next st, dc 2] all round, sl st to close round {23 dc sts}

RND 5 ch 1, dc 1 in same space as prev. sl st, dc 3, [inc in next st, dc 3] all round, sl st to close round {29 dc sts}

RND 6 (working in back sp) ch 1, dc all round, sl st to close round {29 dc sts}

RNDS 7–24 ch 1, dc all round, sl st to close round {29 dc sts} (Replace final sl st with a clean cast off.)

NOTE Thread a tapestry needle with cream yarn and chain stitch between Rows 5 and 6 along the inner edge (you will find that it is easiest to do this after finishing Row 6, rather than waiting until the entire piece is done).

TOP
RND 1 Using cream yarn, dc 6 in magic ring, continue all round in a spiral {6 dc sts}

RND 2 dc all round {6 dc sts}

RND 3 dc 5, inc in next st {7 dc sts}

RND 4 dc 3, inc in next st, dc 3 {8 dc sts}

RND 5 dc 7, inc in next st {9 dc sts}

RND 6 dc 9, sl st {9 dc sts}

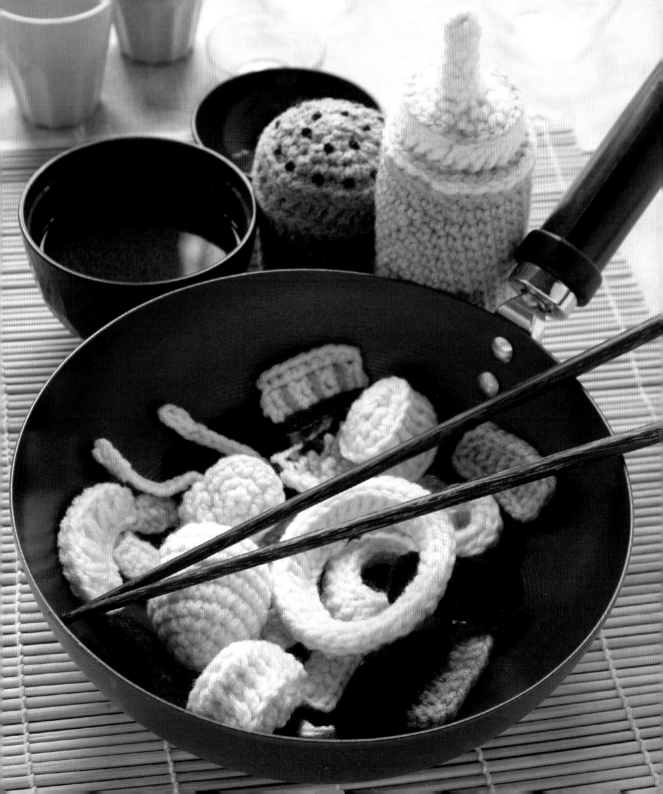

RND 7 (no longer working in a spiral after this point – also, work all sts in this row in front loops only) ch 1, dc 1 in same space as prev. sl st, [inc in next st] all round, sl st to close round {17 dc sts}

RND 8 ch 1, dc 1 in same space as prev. sl st, dc 2, [inc in next st, dc 2] all round, sl st to close round {23 dc sts}

RND 9 (working in back loops only) ch 1, tr all round, sl st to close round {23 dc sts}

RND 10 (working in front loops only) ch 1, dc 1 in same place, dc 3, [inc in next st, dc 3] all round, clean cast off {29 dc sts}

Thread a tapestry needle with buff yarn and chain stitch between Rounds 8 and 9 along the inner edge.

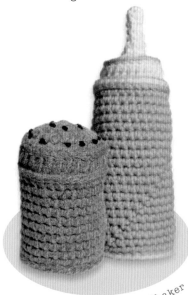

Sauce Bottle and Shaker

TO MAKE UP THE SAUCE BOTTLE
Thread a tapestry needle with buff yarn and link the top and base of the bottle with a chain stitch. When you are halfway round, fill it with stuffing before stitching closed. Weave in any loose yarn ends.

SHAKER
This shaker could dispense pepper or other spices.

YOU ALSO WILL NEED
- A small quantity of DK-weight yarn in grey
- Black six-strand embroidery floss (*you'll be using all six strands*)
- Embroidery needle

RND 1 dc 6 in magic ring, sl st to close round {6 dc sts}

RND 2 ch 1, dc 1 in same space as prev. sl st, [inc in next st] all round, sl st to close round {11 dc sts}

RND 3 ch 1, dc 1 in same space as prev. sl st, dc 1, [inc in next st, dc 1] all round, sl st to close round {17 dc sts}

RND 4 ch 1, dc 1 in same space as prev. sl st, dc 2, [inc in next st, dc 2] all round, sl st to close round {23 dc sts}

RND 5 ch 1, dc 1 in same space as prev. sl st, dc 3, [inc in next st, dc 3] all round, sl st to close round {29 dc sts}

RND 6 (working in back loops) ch 1, dc all round, sl st to close round {29 dc sts} (chain stitch in same colour between Rounds 5 and 6 along inner edge)

RNDS 7 – 15 ch 1, dc all round, sl st to close round {29 dc sts}

RND 16 (working in back loops) ch 2, tr all round, sl st to close round {29 dc sts}

RND 17 (working in back loops) ch 1, dc 2, dec 1st over 2, [dc 3, dec 1st over 2] all round, sl st to close round {23 dc sts}

RND 18 ch 1, dc 1, dec 1st over 2, [dc 2, dec 1st over 2] all round, sl st to close round {17 dc sts} (chain stitch in gray colour between Rounds 15 and 16 along lower edge, and between Rounds 16 and 17 along upper edge)

RND 19 ch 1, dec 1st over 2, [dc 1, dec 1st over 2] all round, sl st to close round {11 dc sts}

RND 20 dc 1, [dec 1st over 2] all round, cast off {5 dc sts}

TO MAKE UP THE SHAKER
Weave in any loose yarn ends, fill the shaker with stuffing and stitch closed using the grey yarn. To make the 'holes', thread an embroidery needle with a length of black floss and make a French knot for each hole, arranging them in one even circle of 12 holes on the outside and one even circle of 6 in the middle of the top.

COURGETTE PIECE

Courgette adds some welcome crunch to a stir-fry.

YOU ALSO WILL NEED

- Small quantities of DK-weight yarn in cream, dark green and yellow
- Sewing needle and thread

ROW 1 using cream yarn, ch 8, dc 7
ROW 2 ch 1, turn, dc 7
ROW 3 ch 1, turn, dc 7, cast off

TO MAKE UP THE COURGETTE PIECE

Thread a tapestry needle with dark green yarn and chain stitch along the edge of the third row of crochet. Rethread your needle with yellow yarn and make three long horizontal stitches across the body (check the photograph for placement). Use a sewing needle and thread to sew down the loose yarn ends along the back of the piece, then knot the end of the thread and stitch it into the body.

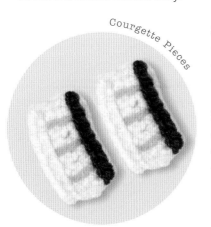
Courgette Pieces

ONION RINGS

These neat yarn onion rings look just like the real thing – each ring segment fits into a larger one to make a realistic onion slice.

YOU ALSO WILL NEED

- A small quantity of DK-weight yarn in cream
- Sewing needle and thread

Make one ring in each size with the cream yarn.

SMALL INNER RING

ch 10, sl st to close round, ch 1, tr all round, clean cast off {9 tr sts}

SMALL OUTER RING

ch 12, sl st to close round, ch 1, tr all round, clean cast off {11 tr sts}

MIDDLE INNER RING

ch 20, sl st to close round, ch 1, tr all round, clean cast off {19 tr sts}

MIDDLE OUTER RING

ch 22, sl st to close round, ch 1, tr all round, clean cast off {21 tr sts}

LARGE INNER RING

ch 32, sl st to close round, ch 1, tr all round, clean cast off {31 tr sts}

LARGE OUTER RING

ch 34, sl st to close round, ch 1, tr all round, clean cast off {33 tr sts}

TO MAKE UP THE ONION RINGS

Take the inner and outer rings for the small piece and fit the inner into the outer, right sides facing out. Thread a sewing needle with cream thread (you need matching thread as a few stitches will inevitably show) and stitch the inner ring into the outer ring, using small neat stitches. Repeat to make the medium and the large onion pieces. The completed pieces should fit together as a neat stack. Weave in any loose yarn ends with a tapestry needle.

Onion Rings

EGG

There's something very satisfying about this oval yarn egg. Of course, you'll eventually have to break it to make your stir-fry, but in the meantime it sits neatly alongside your other ingredients.

YOU ALSO WILL NEED

• A small quantity of DK-weight yarn in cream

RND 1 using cream yarn, dc 6 in magic ring, continue all round in a spiral {6 dc sts}

RND 2 [inc in next st, inc in next st, dc 1] all round {10 dc sts}

RND 3 [inc in next st, dc 1] all round {15 dc sts}

RND 4 [inc in next st, dc 4] all round {18 dc sts}

RND 5 [inc in next st, dc 5] all round {21 dc sts}

RND 6–8 dc all round {21 dc sts}

RND 9 [dec 1 st over 2, dc 5] all round {18 dc sts}

RND 10 [dec 1 st over 2, dc 4] all round {15 dc sts}

RND 11 [dec 1 st over 2, dc 1] all round {10 dc sts}

RND 12 [miss 1, dc 1] 3 times, cast off {5 dc sts}

TO MAKE UP THE EGG
Stuff the crocheted shape tightly with stuffing to make the firm, tidy egg shape, then thread a tapestry needle with cream yarn and sew the open end shut.

PRAWN

The tail of this prawn piece is crocheted in bright pink yarn and stitched details complete its realistic body.

YOU ALSO WILL NEED

• Small quantities of DK-weight yarn in cream and bright pink

Using cream yarn, ch 8, (switch to pink yarn), ch 4, dtr 1 in previous cream ch stitch, ch 1, sl st 1 in front two loops of prev. dtr, ch 1, sl st 1 in same loops as prev. sl st, ch 3, sl st 1 in same st as dtr, (switch to cream yarn), [dc 1, htr 1] in next st, [tr 2 in next st] twice, dtr 1, [dtr 2 in in next st] twice, [dtr 1, tr 1] in next st, ch 2, sl st 1 in same st as prev. tr

TO MAKE UP THE PRAWN Thread a tapestry needle in cream yarn and chain stitch all round the edges of the prawn's body. Weave in any loose yarn ends. Re-thread your needle in pink and stitch 5 'V'-shapes, each made from two single, straight stitches, along the body. Sew yarn end into the body.

BEEF AND CHICKEN STRIPS

These are made in exactly the same way – only the colour of yarn is different.

YOU ALSO WILL NEED

• Small quantities of DK-weight yarn in brown (for the beef) and buff (for the chicken)
• Sewing needle and brown and buff thread

Ch 10, sl st 1, ch 3, dtr 8, cast off, then sl st all round in same colour yarn.

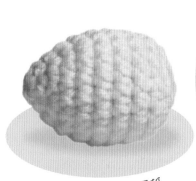

Egg

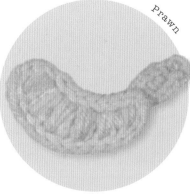

Prawn

TO MAKE UP THE BEEF
AND CHICKEN STRIPS

Use the sewing needle and matching thread to sew down loose yarn ends. Knot the thread and sew the end into the crochet.

SCALLOP

You'll find it easier to stuff this tiny scallop with a few ends of leftover matching yarn rather than use custom-made stuffing.

YOU ALSO WILL NEED

- A small quantity of DK-weight yarn in cream
- Sewing needle and cream thread

RND 1 using cream yarn, dc 6 in magic ring, sl st to close round {6 dc sts}

RND 2 ch 1, dc 1 in same space as prev. sl st, [inc in next st] all round, sl st to close round {11 dc sts}

RND 3 ch 1, dc 2, [htr 2 in next st] 3 times, dc 3, [inc in next st] 3 times, sl st to close round {17 dc sts}

RND 4 (working in back loops only) ch 2, dtr 1, trtr 7, dtr 9, sl st to close round {17 dc sts}

RND 5 (working in back loops only) ch 1, dc 1, [dec 1 st over 2] 3 times, dc 3, [dec 1 st over 2] 3 times, dc 1, sl st to close round {11 dc sts}

RND 6 dc 1, [dec 1 st over 2] 5 times, cast off, stitch closed.

TO MAKE UP THE SCALLOP

Fill with a few pieces of matching yarn and stitch in place. To keep the scallop's sides from gapping, thread the sewing needle in cream and run a thread around the scallop's middle, going through the middle of each side stitch. Pull the thread just tight enough to hold the stitches together, then finish off and sew the end into the body of the scallop.

BEANSPROUT

This is one of the smallest ingredients, yet beansprouts are key in adding texture to a stir-fry. These are tiny so they are best crocheted in quantity.

YOU ALSO WILL NEED

- Small quantities of DK-weight yarn in cream and yellow
- Sewing needle and cream thread

Using cream yarn, ch 8, switch to yellow yarn, ch 4, sl st 2, clean cast off.

TO COMPLETE EACH BEANSPROUT

Thread the sewing needle with cream thread and tack down any loose yarn ends. Sew the end of the thread into the crochet to finish neatly.

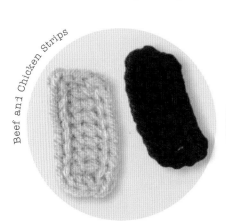

Beef and Chicken Strips

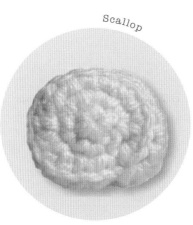

Scallop

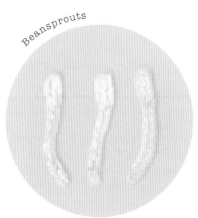

Beansprouts

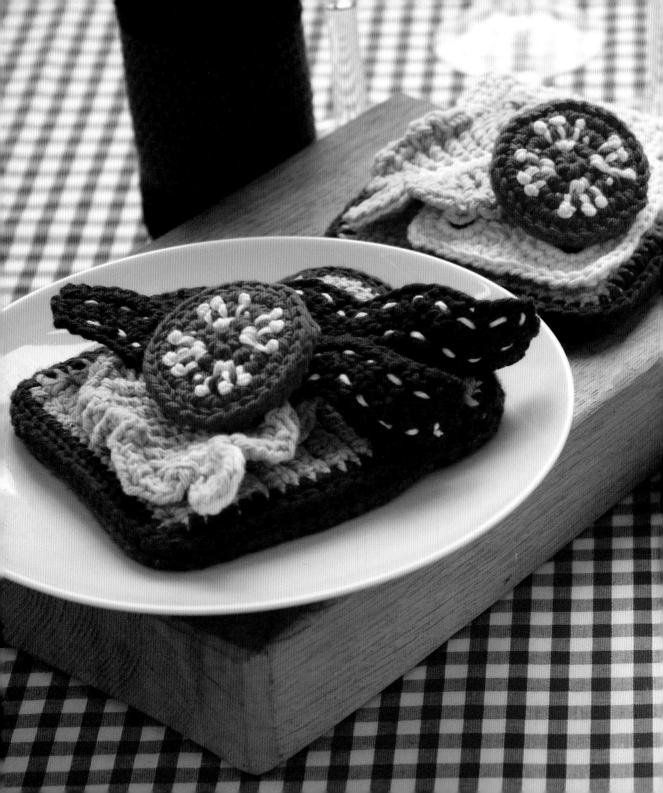

Menu

A BITE TO EAT

SANDWICH BAR
*Bread with a choice of fillings: tomato, lettuce
leaves, bacon or cheese slices*

CHEESE BOARD
*Cheese wedges, Gouda, Camembert,
round and square crackers
Plus a bottle of red wine*

Sandwich bar

What do you like best in a sandwich? Lettuce and tomato? Maybe a rasher or two of crisp bacon so you can have a BLT? Or a slice of cheese? Or any combination of the above? We've included all these – with slices of wholemeal bread to assemble your fillings on. We've left our sandwiches open, Scandinavian style, so that you get a proper look at all the ingredients.

INGREDIENTS
- 3.5 mm (US size E) crochet hook
- DK-weight yarn in the suggested colours (*each pattern calls for only a small amount of each colour of yarn*)
- Tapestry needle (*for weaving in yarn ends and sewing up seams*)
- Scissors
- Some pieces need a little stuffing – unless a different stuffing is specifically listed, choose a lightweight custom toy stuffing

PATTERN TENSION
Using DK-weight yarn and a 3.5 mm (US size E) crochet hook, 5–6 dc x 5–6 rows = 2.5 cm x 2.5 cm (1" x 1")

BREAD SLICE
(*make 3 pieces for each bread slice*)
We've picked slices of wholemeal bread. If you prefer white bread, however, simply pick a cream rather than a beige yarn. If you want a multi-seed slice, you may find that a flecked yarn works well.

YOU ALSO WILL NEED
- Small quantities of DK-weight yarn in beige and brown

ROW 1 using beige yarn, ch 20, dc 19 {19 dc sts}

ROWS 2–15 ch 1, turn, dc 19 {19 dc sts}

ROW 16 ch 1, turn, dc 1, miss 1, dc 15, miss 1, dc 1 {17 dc sts}

ROW 17 ch 1, turn, dc 1, miss 1, dc 13, miss 1, dc 1 {15 dc sts}

ROW 18 ch 1, turn, inc in next st, dc 13, inc in next st {17 dc sts}

ROW 19 ch 1, turn, inc in next st, dc 15, inc in next st {19 dc sts}

ROW 20 ch 1, turn, dc 19 {19 dc sts}

ROW 21 turn, dc 1, tr 1, dtr 6, htr 1, dc 1, htr 1, dtr 6, tr 1, dc 1, clean cast off {18 dc sts}

Using brown yarn, dc around edges of each piece, clean cast off. {78 dc sts}

TO MAKE UP THE BREAD SLICE
Make two more pieces identical to the first one. Stack the three pieces together, aligning the edges and making sure that the top and base pieces are facing right sides out.

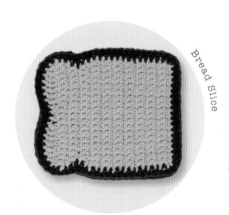

Bread Slice

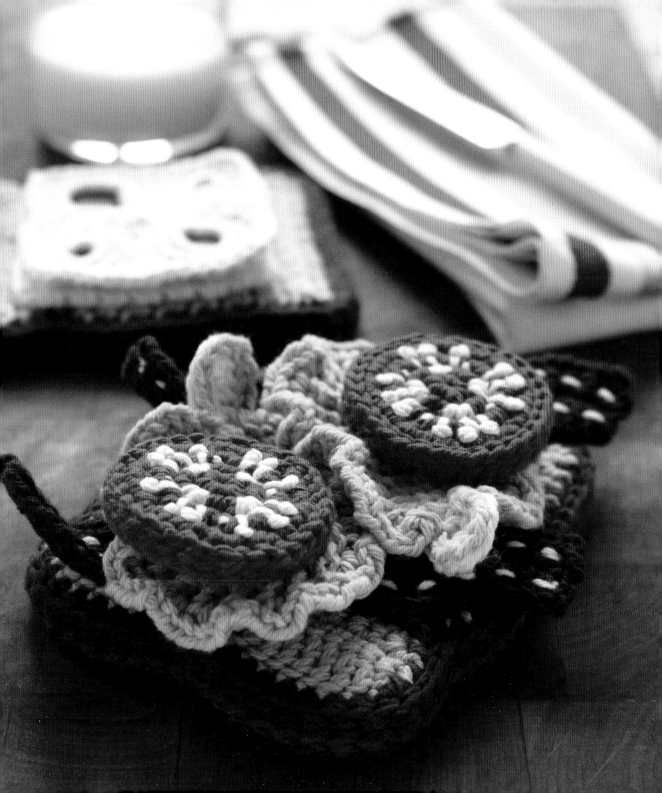

Using brown yarn, sl st all round the edge through all three layers. When you've worked around the bread slice, weave in the yarn end.

TOMATO SLICE

(make 2 pieces for each slice)
Almost any sandwich benefits from a slice or two of tomato.

YOU ALSO WILL NEED
• Small quantities of DK-weight yarn in bright red and cream

RND 1 using bright red yarn, dc 8 in magic ring, sl st to close round {8 dc sts}
RND 2 ch 1, dc 1 in same space as prev. sl st, [switch to cream yarn, inc in next st, switch to red, inc in next st] 3 times, switch to cream yarn, inc in next st, switch to red, sl st close round {15 dc sts}
RND 3 ch 1, dc 1 in same space as prev. sl st, dc 1, [inc in next st, dc 1] all round, sl st to close round {23 dc sts}
RND 4 ch 1, dc 1 in same space as prev. sl st, dc 2, [inc in next st, dc 2] all round, clean cast off {31 dc sts}

TO MAKE UP THE TOMATO SLICE
When you have worked two identical pieces, thread a tapestry needle with cream yarn and work the stitch detail shown in the photograph. Weave in the ends on the wrong side. Stack the pieces together, right sides facing out. Using red yarn, sl st all round the edges through both layers, sandwiching them together.

LETTUCE LEAF

Add some lettuce to balance the high-protein sandwich options.

YOU ALSO WILL NEED
• Small quantities of DK-weight yarn in bright green and cream

Using cream yarn, ch 15, dtr 1 in 3rd loop from hook, dtr 2, tr 3, htr 2, dc 5, clean cast off.

Using green yarn, with right side facing join before 2nd tr and working towards the narrow end, ch 1, tr 2 in next st, dtr 2, trtr 2, quad tr 2, quad tr 3 in next st, quad tr 4 in next st, quad tr 3 in next st, quad tr 2, trtr 2, dtr 2, tr 2 in 1, ch 1, sl st 12 [dc 1, ch 1, dc 1 in same place as last dc, ch 1] 26 times, sl st, cast off.

TO COMPLETE THE LETTUCE LEAF
Simply weave in any loose yarn ends.

BACON RASHER

You'll probably want two or three of rashers of bacon, but they're very easy to make.

YOU ALSO WILL NEED
• Small quantities of DK-weight yarn in burgundy and white

ROW 1 using burgundy yarn, ch 31, [dc 3, inc in next st, dc 3, dec over 2 sts] 3 times, dc 3 {30 dc sts}

Bacon Rasher

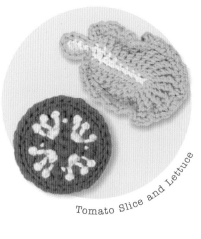

Tomato Slice and Lettuce

ROW 2 ch 1, turn, [dc 3, dec over 2 sts, dc 3, inc in next st] 3 times, dc 3 {30 dc sts}

ROW 3 ch 1, turn, [dc 3, inc in next st, dc 3, dec over 2 sts] 3 times, dc 3 {30 dc sts}

ROW 4 ch 1, turn, [dc 3, dec over 2 sts, dc 3, inc in next st] 3 times, dc 3, cast off {30 dc sts}

TO COMPLETE THE BACON RASHER

Thread a tapestry needle with white yarn and stitch two lines of running stitch along the length of the rasher, finishing off and stitching the ends into the crochet.

CHEESE SLICE

(pattern 1)

We've supplied two different cheese patterns for you to try.

YOU ALSO WILL NEED

- A small quantity of DK-weight yarn in cream

Cheese Slice 1 and 2

- Sewing needle and tan thread
- Small scrap of tan felt

ROW 1 using cream yarn, ch 16, dc 15 {15 dc sts}

ROWS 2–15 ch 1, turn, dc 15 {15 dc sts}, cast off

TO MAKE UP THE CHEESE SLICE 1

Weave in any loose ends of yarn. Cut four circles of tan felt, two about 2.5 cm (1 in), and two about 1.25 cm (½ in) in diameter. Thread the sewing needle with tan thread and neatly sew the circles onto the finished cheese slice.

CHEESE SLICE

(pattern 2)

This second version of the cheese slice is made from four pieces.

YOU ALSO WILL NEED

- A small quantity of DK-weight yarn in cream

Make 1

RND 1 using cream yarn, dc 16 in magic ring and do not pull ring very tight when done. The hole in the centre should be about 1.25 cm (½ in) across, sl st to close round {16 dc sts}

RND 2 ch 1, dc 1 in same space as prev. sl st, dc 3, [inc in next st, dc 3] 3 times, clean cast off {19 dc sts}

Make 2

RND 1 using cream yarn, dc 12 in magic ring and do not pull ring very tight when done. The hole in the centre should be about 0.75 cm (¼ in) across, continue all round in a spiral {12 dc sts}

RND 2 dc 1, tr 4 in next st, tr 1, [tr 1, dtr 2, tr 1] in next st, tr 1, [tr 1, htr 1, dc 1] in next st, sl st 1, clean cast off {14 dc sts}

Make 1

RND 1 using cream yarn, dc 20 in magic ring and do not pull ring very tight when done. The hole in the centre should be about 2 cm (¾ in) across, clean cast off {20 dc sts}

TO MAKE UP THE CHEESE SLICE 2

Using a tapestry needle threaded with matching yarn, whipstitch the four pieces just made together into a 2 x 2 grid. Each piece connects to another with a 5-stitch-long seam. See the photograph of the finished piece for placement.

Join again in any corner of the 2 x 2 grid just made. Ch 2, dc 1 in same space as the join, dc 4, tr 2, dc 4, [[dc 1, htr 1] in next st, [htr 1, dc 1] in next st, dc 4, tr 2, dc 4] 3 times, [dc 1, htr 1] in next st, clean cast off. {55 dc sts}

Weave in any loose yarn ends.

Cheese board

What could be more civilized than a glass of wine with a piece of good cheese? Not only does this selection offer a generous cheese board, whether your taste runs to a Gouda or a ripe, delicious Camembert, but there's a choice of crackers and a bottle of robust red wine to enjoy with it too.

INGREDIENTS

- 3.5 mm (US size E) crochet hook
- DK-weight yarn in the suggested colours (*each pattern calls for only a small amount of each colour of yarn*)
- Tapestry needle (*for weaving in yarn ends and sewing up seams*)
- Scissors
- **Some pieces need a little stuffing – unless an alternative is specifically listed, choose a lightweight custom toy stuffing**

PATTERN TENSION
Using DK-weight yarn and a 3.5 mm (US size E) crochet hook, 5–6 dc x 5–6 rows = 2.5 cm x 2.5 cm (1" x 1")

WINE BOTTLE
A full-bodied red will be perfect with cheese and crackers.

YOU ALSO WILL NEED

- Small quantities of DK-weight yarn in plum, deep green and black
- A rectangular piece of fleece material, about 12.5 cm (5 in) deep by 30 cm (12 in) long
- Sewing needle and plum-coloured thread

BOTTLE
RND 1 using black yarn, dc 6 in magic ring, sl st to close round {6 dc sts}

RND 2 ch 1, dc 1 in same, [inc in next st] all round, sl st to close round {11 dc sts}

RND 3 ch 1, dc 1 in same, dc 1, [inc in next st, dc 1] all round, sl st to close round {17 dc sts}

RND 4 ch 1, dc 1 in same, dc 2, [inc in next st, dc 2] all round, sl st to close round {23 dc sts}

RND 5 ch 1, dc 1 in same, dc 3, [inc in next st, dc 3] all round, sl st to close round {29 dc sts}

RND 6 ch 1, dc 1 in same, dc 4, [inc in next st, dc 4] all round, sl st to close round {35 dc sts}

RND 7 ch 1, working in back loops only, dc all round, sl st to close round {35 dc sts}

RNDS 8–10 ch 1, dc all round, switch to plum yarn, sl st to close round {35 dc sts}

RND 11 ch 1, dc all round, switch to deep green yarn, sl st to close round {35 dc sts}

RND 12 ch 1, dc all round, sl st to close round {35 dc sts}

Stop here and, using plum yarn, sl st all round between Rounds 10 and 11, and again between Rounds 11 and 12.

RNDS 13–23 ch 1, dc all round, switch to plum yarn, sl st to close round {35}

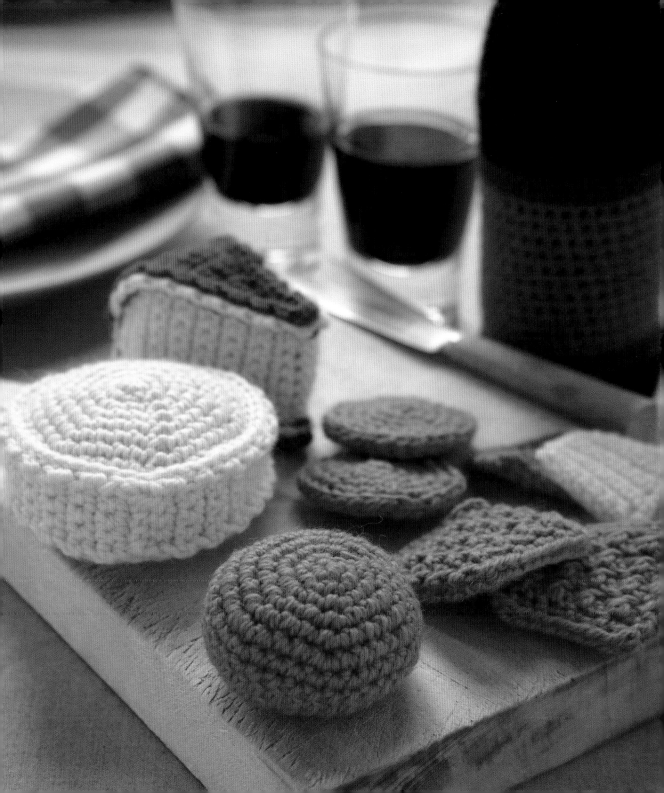

RND 24 ch 1, dc all round, switch to black yarn, sl st to close round {35}

RNDS 25–31 ch 1, dc all round, sl st to close round {35}

At this point, stuff the body of your wine bottle using the piece of fleece fabric. Roll the fleece into a short tube along the 12.5 cm (5 in) edge, which should create a cylinder about 7 cm (2¾ in) diameter. Push this gently into the body of the wine bottle. Using fleece will help the bottle to stand upright and give it a good even shape.

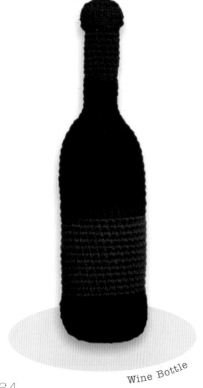

Wine Bottle

RND 32 ch 1, dc 9, dec over 2 sts, [dc 10, dec over 2 sts] twice, sl st to close round {32 dc sts}

RND 33 ch 1, dc all round, sl st to close round {32 dc sts}

RND 34 ch 1, dc 8, dec over 2 sts, [dc 9, dec over 2 sts] twice, sl st to close round {29 dc sts}

RND 35 ch 1, dc all round, sl st to close round {29 dc sts}

RND 36 ch 1, dc 2, dec over 2 sts, [dc 3, dec over 2 sts] all round, sl st to close round {23 dc sts}

RND 37 ch 1, dc 1, dec over 2 sts, [dc 2, dec over 2 sts] all round, sl st to close round {17 dc sts}

RND 38 ch 1, dc 3, dec over 2 sts, [dc 4, dec over 2 sts] all round, sl st to close round {14 dc sts}

RNDS 39–42 ch 1, dc all round, sl st to close round {14 dc sts}

RND 43 ch 1, dc all round, switch to plum yarn, sl st to close round {14 dc sts}

RND 44 ch 1, dc all round, sl st to close round {14 dc sts}

Stop at this point and, using plum yarn, sl st all round between Rounds 43 and 44.

RNDS 45–54 ch 1, dc all round, sl st to close round {14 dc sts}, replacing the final sl st with a clean cast off

CAP

RND 1 Using plum yarn, dc 6 in magic ring, sl st to close round {6 dc sts}

RND 2 ch 1, dc 1 in same, [inc in next st] all round, sl st to close round {11 dc sts}

RND 3 ch 1, dc 1 in same, dc 1, [inc in next st, dc 1] all round, sl st to close round {17 dc sts}

RND 4 ch 1, working in back loops only, tr all round, sl st to close round {17 dc sts}

TO COMPLETE THE WINE BOTTLE
Fill the remaining empty space in the bottle with toy stuffing. Put the cap over the bottle's neck and sew it into place using a sewing needle and thread.

CHEESE WEDGE

This piece of cheese has a rich red rind and a creamy interior.

YOU ALSO WILL NEED
• Small quantities of DK-weight yarn in deep red and cream

CHEESE RIND
ROW 1 using deep red yarn, ch 2, inc in next st {2 dc sts}

ROW 2 ch 1, turn, dc 2 {2 dc sts}

ROW 3 ch 1, turn, dc 1, inc in next st {3 dc sts}

ROW 4 ch 1, turn, dc 3 {3 dc sts}

ROW 5 ch 1, turn, inc in next st, dc 2 {4 dc sts}

ROW 6 ch 1, turn, dc 4 {4 dc sts}

ROW 7 ch 1, turn, dc 3, inc in next st {5 dc sts}

ROW 8 ch 1, turn, dc 5 {5 dc sts}

ROW 9 ch 1, turn, inc in next st, dc 4 {6 dc sts}

ROW 10 ch 1, turn, dc 6 {6 dc sts}

ROW 11 ch 1, turn, dc 5, inc in next st {7 dc sts}

ROW 12 ch 1, turn, dc 7 {7 dc sts}

ROW 13 ch 1, turn, inc in next st, dc 6 {8 dc sts}

ROWS 14–24 ch 1, turn, dc 8 {8 dc sts}

ROW 25 ch 1, turn, miss 1, dc 7 {7 dc sts}

ROW 26 ch 1, turn, dc 7 {7 dc sts}

ROW 27 ch 1, turn, dc 5, miss 1, dc 1 {6 dc sts}

ROW 28 ch 1, turn, dc 6 {6 dc sts}

ROW 29 ch 1, turn, miss 1, dc 5 {5 dc sts}

ROW 30 ch 1, turn, dc 5 {5 dc sts}

ROW 31 ch 1, turn, dc 3, miss 1, dc 1 {4 dc sts}

ROW 32 ch 1, turn, dc 4 {4 dc sts}

ROW 33 ch 1, turn, miss 1, dc 3 {3 dc sts}

ROW 34 ch 1, turn, dc 3 {3 dc sts}

ROW 35 ch 1, turn, dc 1, miss 1, dc 1 {2 dc sts}

ROW 36 ch 1, turn, dc 2 {2 dc sts}

ROW 37 ch 1, turn, miss 1, dc 1, cast off {1 dc st}

BODY OF CHEESE
(make 2 for each wedge)

ROW 1 using cream yarn, ch 10, dc 9 {9 dc sts}

ROWS 2–14 ch 1, turn, dc 9 {9 dc sts}

ROW 15 ch 1, turn, miss 1, dc 6, miss 1, dc 1 {7 dc sts}

ROW 16 ch 1, turn, miss 1, dc 4, miss 1, dc 1 {5 dc sts}

Using cream yarn, whipstitch around the beginning edge (Row 1) of both cheese body pieces.

TO MAKE UP THE CHEESE WEDGE
Wrap the cheese rind over the 'v' formed by the two cheese body pieces (the points at the beginning and end of the rind fit into the top and bottom points of the 'v'). Using deep red yarn, sl st all round the edges, with each stitch worked through both the rind and the cheese body. Fill with stuffing until the wedge feels solid before stitching fully closed.

GOUDA

(make 2 pieces for each cheese)
This whole Gouda should last you for some time, especially since it is made of 100 per cent wool.

YOU ALSO WILL NEED
• A small quantity of DK-weight yarn in gold

RND 1 using gold yarn, dc 6 in magic ring, sl st to close round {6 dc sts}

RND 2 ch 1, dc 1 in same space as prev. sl st, [inc in next st] all round, sl st to close round {11 dc sts}

RND 3 ch 1, dc 1 in same space as prev. sl st, dc 1, [inc in next st, dc 1] all round, sl st to close round {17 dc sts}

RND 4 ch 1, dc 1 in same space as prev. sl st, dc 2, [inc in next st, dc 2] all round, sl st to close round {23 dc sts}

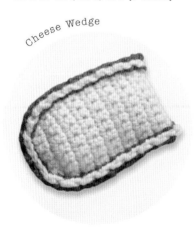

Cheese Wedge

Gouda

RND 5 ch 1, dc 1 in same space as prev. sl st, dc 3, [inc in next st, dc 3] all round, sl st to close round {29 dc sts}

RND 6 ch 1, dc 1 in same space as prev. sl st, dc 4, [inc in next st, dc 4] all round, sl st to close round {35 dc sts}

RND 7 ch 1, dc all round, clean cast off {35 dc sts}

TO MAKE UP YOUR GOUDA
When you have made the second piece, set one piece over the other, with the right sides facing out.

Using matching yarn, whipstitch the two pieces together around the edges. Fill with stuffing until the cheese is firmly packed before stitching fully closed.

CAMEMBERT

In contrast to the Gouda, this soft cheese would go especially well with a rough-textured cracker and some of the celery sticks from the vegetable platter.

YOU ALSO WILL NEED
• A small quantity of DK-weight yarn in cream

TOP AND BASE
(make 2 for each cheese)
RND 1 using cream yarn, dc 6 in magic ring, sl st to close round {6 dc sts}

RND 2 ch 1, dc 1 in same space as prev. sl st, [inc in next st] all round, sl st to close round {11 dc sts}

RND 3 ch 1, dc 1 in same space as prev. sl st, dc 1, [inc in next st, dc 1] all round, sl st to close round {17 dc sts}

RND 4 ch 1, dc 1 in same space as prev. sl st, dc 2, [inc in next st, dc 2] all round, sl st to close round {23 dc sts}

RND 5 ch 1, dc 1 in same space as prev. sl st, dc 3, [inc in next st, dc 3] all round, sl st to close round {29 dc sts}

RND 6 ch 1, dc 1 in same space as prev. sl st, dc 4, [inc in next st, dc 4] all round, sl st to close round {35 dc sts}

RND 7 ch 1, dc 1 in same space as prev. sl st, dc 5, [inc in next st, dc 5] all round, sl st to close round {41 dc sts}

RND 8 ch 1, dc 1 in same space as prev. sl st, dc 6, [inc in next st, dc 6] all round, sl st to close round {47 dc sts}

SIDE PIECE
ROW 1 using cream yarn, ch 5, dc 4 {4 dc sts}
ROWS 2–48 ch 1, turn, dc 4 {4 dc sts}
TO MAKE UP THE CAMEMBERT
Thread a tapestry needle with cream yarn and whipstitch the beginning and end of the side piece strip together to form a ring.

Set one of the top pieces over the ring and align the edges. Using matching yarn, sl st all round the edge, working each stitch through both the top piece layer and the side piece layer. Repeat to attach the base to the cheese, filling firmly with stuffing before stitching fully closed.

SMALL INDIVIDUAL PIECES OF CHEESE

A few ready-cut slivers of cheese can be laid around your cheese board for added verisimilitude.

YOU ALSO WILL NEED
• Small quantities of DK-weight yarn in cream and gold

ROW 1 ch 8, dc 7 {7 dc sts}
ROWS 2–8 ch 1, turn, dc 7 {7 dc sts}
TO COMPLETE THE CHEESE PIECES
Cast off and weave in any loose ends.

Camembert

ROUND CRACKER

(make 2 pieces for each cracker)

This cheese board includes two sorts of cracker as well as three types of cheese.

YOU ALSO WILL NEED

• A small quantity of DK-weight yarn in light brown.

RND 1 using brown yarn, dc 6 in magic ring, sl st to close round {6 dc sts}

RND 2 ch 1, dc 1 in same space as prev. sl st, [inc in next st] all round, sl st to close round {11 dc sts}

RND 3 ch 1, dc 1 in same space as prev. sl st, dc 1, [inc in next st, dc 1] all round, sl st to close round {17 dc sts}

RND 4 ch 1, dc 1 in same space as prev. sl st, dc 2, [inc in next st, dc 2] all round, sl st to close round {23 dc sts}

RND 5 ch 1, dc 1 in same space as prev. sl st, dc 3, [inc in next st, dc 3] all round, clean cast off {29 dc sts}

TO COMPLETE THE ROUND CRACKER

When you've finished the second piece, stack both together, right sides facing out. Thread a tapestry needle with matching yarn and whipstitch around the edges of the stack, sandwiching the pieces together. Finish off the yarn neatly, sewing the end into the centre of the cracker.

SQUARE CRACKER

(make 2 pieces for each cracker)

This cracker is perfect with a soft cheese such as Camembert.

YOU ALSO WILL NEED

• A small quantity of DK-weight yarn in light brown

ROW 1 using light brown yarn, ch 10, dc 9 {9 dc sts}

ROW 2 ch 1, turn, working in front loops only, dc 9 {9 dc sts}

ROW 3 ch 1, turn, [dc 1, tr 1 in one of the back loops left open from the prev. row] 4 times, dc 1 {9 dc sts}

ROW 4 same as Row 2 {9 dc sts}

ROW 5 same as Row 3 {9 dc sts}

ROW 6 same as Row 2 {9 dc sts}

ROW 7 same as Row 3 {9 dc sts}

ROW 8 same as Row 2 {9 dc sts}

ROW 9 same as Row 3 {9 dc sts}

ROW 10 ch 1, turn, dc 9, cast off {9 dc sts}

TO COMPLETE THE SQUARE CRACKER

When you've finished the second piece, stack both together, right sides facing out. Thread a tapestry needle with matching yarn and whipstitch around the edges of the stack, sandwiching the pieces together. Finish off the yarn neatly, sewing the end into the centre of the cracker.

Round Cracker

Square Cracker

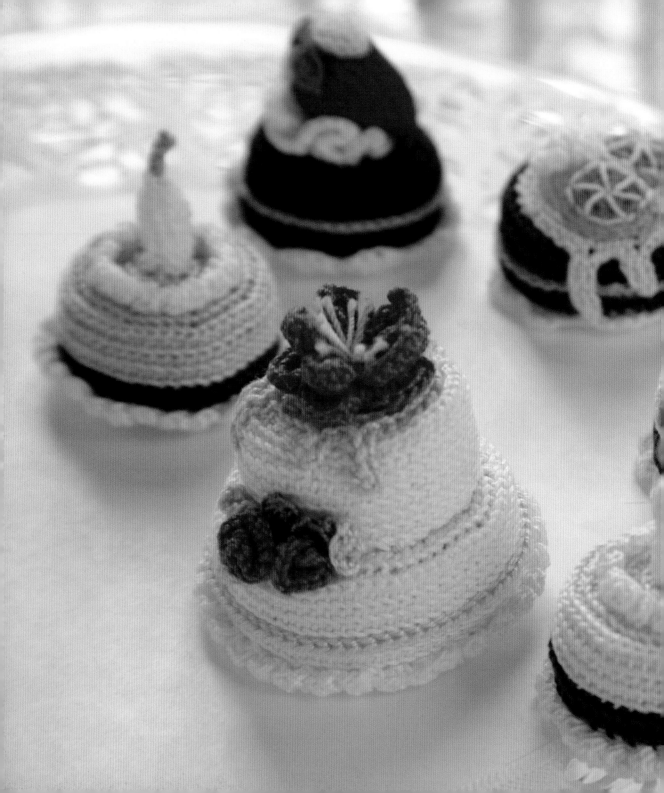

Menu

YARN PATISSERIE

SWEET TREATS

*Cherry, orange and
strawberry cakes
Two-tier wedding cake
Birthday cake with candle*

Sweet treats

The cakes in this chapter have been crocheted with fine cotton and are very petite and delicate. If you're new to crochet, make a start with some of the simpler patterns (such as those in the sushi section) before tackling these. Although these are harder to make, the results are cute and truly appetizing.

INGREDIENTS
- 1.3 mm (US size 10) steel crochet hook
- Mercerized crochet cotton, size 20–30, in the suggested colours (*each pattern calls for only a small amount of each colour of cotton*)
- Sewing needle (*for weaving in ends and sewing up seams*)
- Scissors
- Stuffing – choose a lightweight custom toy stuffing

NOTE
You can also use plastic bottle tops to 'fill' the smaller cakes for a very neat, crisp outline, although you may need to experiment with different bottle tops to find a perfect fit.

PATTERN TENSION
Using size 20 crochet cotton and a 1.3 mm (US size 10) steel hook, 11 dc = 2.5 cm (1")

CHERRY CAKE
A pair of delicious, fresh-looking cherries tops this miniature cake.

YOU ALSO WILL NEED
- Small quantities of crochet cotton size 20-30 in beige, white, orange, red, brown and bright green
- Sewing needle and thread

CAKE BODY
RND 1 using beige crochet cotton, dc 7 in magic ring {7 dc sts}
RND 2 dc 2 in each st all round {14 dc sts}
RND 3 [dc 1 in next st, dc 2 in next st] all round {21 dc sts}
RND 4 [dc 1 in next 2 sts, dc 2 in next st] all round {28 dc sts}
RND 5 [dc 1 in next 3 sts, dc 2 in next st] all round {35 dc sts}
RND 6 [dc 1 in next 4 sts, dc 2 in next st] all round {42 dc sts}
RND 7 dc 1 in each st all round in back loop {42 dc sts}

RNDS 8–9 dc 1 in each st all round {42 dc sts}
RNDS 10–11 using brown crochet cotton, dc 1 in each st all round {42 dc sts}, cast off

CAKE BASE
RND 1 using white crochet cotton, dc 7 in magic ring {7 dc sts}
RND 2 dc 2 in each st all round {14 dc sts}
RND 3 [dc 1 in next st, dc 2 in next st] all round {21 dc sts}
RND 4 [dc 1 in next 2 sts, dc 2 in next st] all round {28 dc sts}
RND 5 [dc 1 in next 3 sts, dc 2 in next st] all round {35 dc sts}
RND 6 [dc 1 in next 4 sts, dc 2 in next st] all round {42 dc sts}
RND 7 [dc 1 in next 5 sts, dc 2 in next st] all round {49 dc sts}, sl st
RND 8 chain 1, [2 htr in next st, 1 sl st in next st] all round, cast off

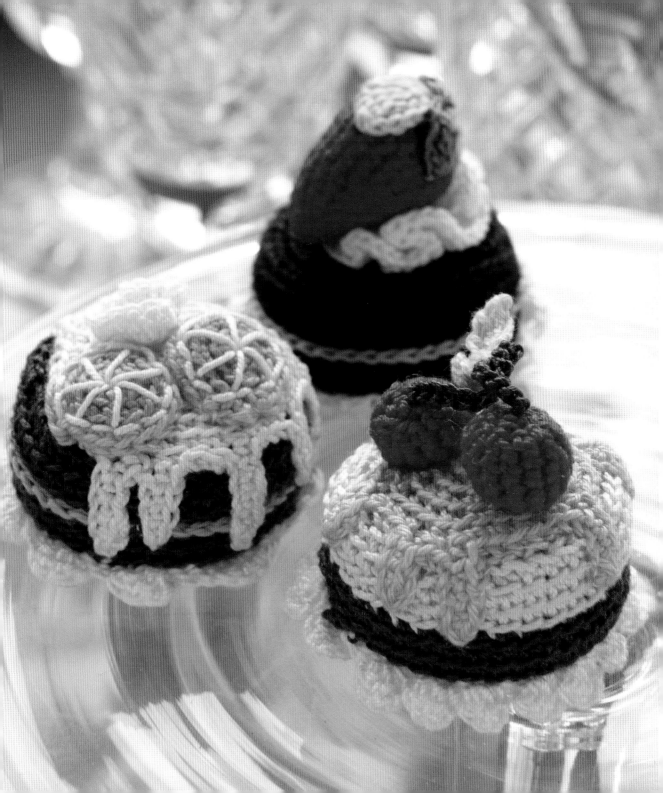

ICING

RND 1 using orange crochet cotton, dc 7 in magic ring {7 dc sts}

RND 2 dc 2 in each st all round {14 dc sts}

RND 3 [dc 1 in next st, dc 2 in next st] all round {21 dc sts}

RND 4 [dc 1 in next 2 sts, dc 2 in next st] all round {28 dc sts}

RND 5 Chain 4, into second chain from hook work dc 1, dc 1 into each remaining chain, dc 1 into next 3 sts

ch 4, into 2nd ch from hook work dc 1, dc 1 into rem. ch, dc 1 into next st

ch 5, into 2nd ch from hook work dc 1, dc 1 into rem. ch, dc 1 into next 6 sts

ch 4, into 2nd ch from hook work dc 1, dc 1 into rem. ch, dc 1 into next 4 sts

ch 3, into 2nd ch from hook work dc 1, dc 1 into rem. ch, dc 1 into next 6 sts

ch 4, into 2nd ch from hook work dc 1, dc 1 into rem. ch, dc 1 into next st

ch 3, into 2nd ch from hook work dc 1, dc 1 into rem. ch, sl st into beg. Round 5, cast off.

CHERRY

(make 2)

RND 1 using red crochet cotton, dc 9 in magic ring {9 dc sts}

RND 2 dc 2 in each st all round {18 dc sts}

RNDS 3–6 dc 1 in each st all round {18 dc sts}

RND 7 dec over 2 sts all round {9 dc sts}, cast off

LEAVES

Using bright green crochet cotton, ch 4, tr in the 4th ch from hook, ch 4, sl st in the very first ch, ch 4, tr in the 4th ch from hook, ch 4, sl st in the very first ch, cast off.

STALKS

Using brown crochet cotton, chain 18, cast off. Fold in half and stitch the leaves on the fold line. Using a sewing needle and thread, stitch a cherry onto the end of each stalk.

TO MAKE UP THE CHERRY CAKE

Using a needle and thread, stitch the icing onto the top of the cake, then stitch the cherries onto the icing. Check the photograph of the finished piece for placement.

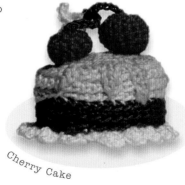

Cherry Cake

Stuff the cake and stitch the cake base in place. (See the note at the beginning of the chapter about bottle tops as an alternative 'filling'.)

ORANGE CAKE

Tasty orange slices and a generous dollop of cream top off this chocolate sponge mini-cake.

YOU ALSO WILL NEED

- Small quantities of crochet cotton size 20-30 in brown, white, light orange, deep orange and yellow
- Sewing needle and thread

CAKE BODY

RND 1 using brown crochet cotton, dc 7 in magic ring {7 dc sts}

RND 2 dc 2 in each st all round {14 dc sts}

RND 3 [dc 1 in next st, dc 2 in next st] all round {21 dc sts}

RND 4 [dc 1 in next 2 sts, dc 2 in next st] all round {28 dc sts}

RND 5 [dc 1 in next 3 sts, dc 2 in next st] all round {35 dc sts}

RND 6 [dc 1 in next 4 sts, dc 2 in next st] all round {42 dc sts}

RND 7 dc 1 in each st all round in back loop {42 dc sts}

RNDS 8–11 dc 1 in each st all round {42 dc sts}, cast off

CAKE BASE

RND 1 using white crochet cotton, dc 7 in magic ring {7 dc sts}

RND 2 dc 2 in each st all round {14 dc sts}

RND 3 [dc 1 in next st, dc 2 in next st] all round {21 dc sts}

RND 4 [dc 1 in next 2 sts, dc 2 in next st] all round {28 dc sts}

RND 5 [dc 1 in next 3 st, dc 2 in next st] all round {35 dc sts}

RND 6 [dc 1 in next 4 sts, dc 2 in next st] all round {42 dc sts}

RND 7 [dc 1 in next 5 sts, dc 2 in next st] all round {49 dc sts}, sl st

RND 8 ch 1, [3 htr in next st, 1 sl st in next 3 st] all round, cast off

FILLING

Using light orange crochet cotton, pull a loop through one of the stitches of the 9th round of the cake, [sl st in next st] all round, cast off.

ICING

RND 1 using yellow crochet cotton, dc 7 in magic ring {7 dc sts}

RND 2 dc 2 in each st all round {14 dc sts}

RND 3 [dc 1 in next st, dc 2 in next st] all round {21 dc sts}

RND 4 [dc 1 in next 2 sts, dc 2 in next st] all round {28 dc sts}

RND 5 [dc 1 in next 3 sts, dc 2 in next st] all round {35 dc sts}

RND 6 ch 5, into second ch from hook work dc 1, dc 1 into each remaining ch, dc 1 into next 9 sts, ch 5, into 2nd ch from hook work dc 1, dc 1 into rem. ch, dc 1 into next st, ch 4, into 2nd ch from hook work dc 1, dc 1 into rem. ch, dc 1 into next 3 sts, ch 5, into 2nd ch from hook work dc 1, dc 1 into rem. ch, dc 1 into next 3 sts, ch 3, into 2nd ch from hook work dc 1, dc 1 into rem. ch, dc 1 into next 2 sts, ch 6, into 2nd ch from hook work dc 1, dc 1 into rem. ch, dc 1 into rem. st, sl st into first to join, cast off

CREAM PUFF

Using white crochet cotton, ch 9, dc 3 in 2nd ch from hook, dc 3 in each ch across, cast off.

ORANGE SLICE
(make 2)

RND 1 using dark orange crochet cotton, dc 7 in magic ring {7 dc sts}

RND 2 dc 2 in each st all round {14 dc sts}

RND 3 [dc 1 in next st, dc 2 in next st] all round {21 dc sts}

RND 4 using light orange crochet cotton, [dc 1 in next 2 sts, dc 2 in next st] all round {28 dc sts}, cast off

TO MAKE UP THE ORANGE CAKE

Thread a sewing needle with a length of yellow crochet cotton and make a line of backstitch all round the edge of each orange slice and six radiating lines to mark the orange 'segments' on each piece. Use the photograph of the finished piece to check placement. Stitch the icing on the top of the brown cake. Stitch the two orange slices and the cream puff on to the icing. Stuff the cake body, then stitch the base into place. (See the note at the beginning of the chapter about bottle tops as an alternative 'filling'.)

STRAWBERRY CAKE

A perfect strawberry alongside a dollop of cream make up a classic garnish for this cake.

YOU ALSO WILL NEED

- Small quantities of crochet cotton size 20–30 in white, pink, brown, red, bright green and dark green
- Sewing needle and thread

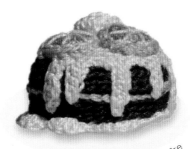

Orange Cake

CAKE BODY

RND 1 using brown crochet cotton, dc 7 in magic ring {7 dc sts}

RND 2 dc 2 in each st all round {14 dc sts}

RND 3 [dc 1 in next st, dc 2 in next st] all round {21 dc sts}

RND 4 [dc 1 in next 2 sts, dc 2 in next st] all round {28 dc sts}

RND 5 [dc 1 in next 3 sts, dc 2 in next st] all round {35 dc sts}

RND 6 [dc 1 in next 4 sts, dc 2 in next st] all round {42 dc sts}

RND 7 dc 1 in each st all round in back loop {42 dc sts}

RNDS 8–11 dc 1 in each st all round {42 dc sts}, cast off

CAKE BASE

RND 1 using white crochet cotton, dc 7 in magic ring {7 dc sts}

RND 2 dc 2 in each st all round {14 dc sts}

RND 3 [dc 1 in next st, dc 2 in next st] all round {21 dc sts}

RND 4 [dc 1 in next 2 sts, dc 2 in next st] all round {28 dc sts}

Strawberry Cake

RND 5 [dc 1 in next 3 sts, dc 2 in next st] all round {35 dc sts}

RND 6 [dc 1 in next 4 sts, dc 2 in next st] all round {42 dc sts}

RND 7 [dc 1 in next 5 sts, dc 2 in next st] all round {49 dc sts}, sl st

RND 8 [htr 1 in next st, tr 3 in next st, htr 1 in next st, 1 sl st in next st] all round, cast off

FILLING

Using pink crochet cotton, pull a loop through one of the stitches of the 9th round of the cake, [sl st in next st] all round, cast off.

CREAM PUFF

RND 1 using white crochet cotton, dc 7 in magic ring {7 dc sts}

RND 2 dc 2 in each st all round {14 dc sts}

RND 3 4 htr in each st all round {56 dc sts}, cast off

STRAWBERRY

RND 1 using red crochet cotton, dc 7 in magic ring {7 dc sts}

RND 2 dc 2 in each st all round {14 dc sts}

RND 3 [dc 1 in next st, dc 2 in next st] all round {21 dc sts}

RNDS 4–6 dc 1 in next st all round {21 dc sts}

RND 7 [dec over 2 sts, dc 1 in next 5 sts] all round {18 dc sts}

RND 8 [dec over 2 sts, dc 1 in next 4 sts] all round {15 dc sts}

RND 9 [dec over 2 sts, dc 1 in next 3 sts] all round {12 dc sts}

RND 10 [dec over 2 sts, dc 1 in next 2 sts] all round {9 dc sts}

RND 11 [dec over 2 sts, dc 1 in next st] all round {6 dc sts}, cast off

LEAVES

Using bright green crochet cotton, ch 4, tr in the 4th ch from hook, ch 4, sl st in the very first ch, ch 4, tr in the 4th ch from hook, ch 4, sl st in the very first ch, ch 4, tr in the 4th ch from hook, ch 4, sl st in the very first ch, cast off.

Using dark green, ch 4, tr in the 4th ch from hook, ch 4, sl st in the very first ch, ch 4, tr in the 4th ch from hook, ch 4, sl st in the very first ch, cast off.

TO MAKE UP THE STRAWBERRY CAKE

Thread a sewing needle with white cotton and stitch the cream puff onto the top of the cake. Re-thread the needle with red cotton and stitch the leaves onto the strawberry and then the strawberry onto the top of the cake (check the photograph of the finished piece for placement). Fill the cake and stitch the base piece in place. (See the note at the beginning of the chapter about the use of bottle tops as an alternative 'filling'.)

WEDDING CAKE

What couple wouldn't choose this two-tier wonder for their big day? The cake is topped by elaborate 'icing' flowers and decorations. If you want to make the cake larger, you can experiment with slightly thicker cotton and a larger hook, but make a swatch first.

YOU ALSO WILL NEED

• Small quantities of crochet cotton size 20-30 in white, pale pink, deep pink, dark green and bright green. Tiny quantities of orange and yellow cotton are optional but may be used for extra stitched details.

LOWER LAYER

RND 1 using white crochet cotton, dc 7 in magic ring {7 dc sts}

RND 2 dc 2 in each st all round {14 dc sts}

RND 3 [dc 1 in next st, dc 2 in next st] all round {21 dc sts}

RND 4 [dc 1 in next 2 sts, dc 2 in next st] all round {28 dc sts}

RND 5 [dc 1 in next 3 sts, dc 2 in next st] all round {35 dc sts}

RND 6 [dc 1 in next 4 sts, dc 2 in next st] all round {42 dc sts}

RND 7 [dc 1 in next 5 sts, dc 2 in next st] all round {49 dc sts}

RND 8 [dc 1 in next 6 sts, dc 2 in next st] all round {56 dc sts}

RND 9 dc in each st all round in back loop {56 dc sts}

RNDS 10–13 dc 1 in each st all round {56 dc sts}, cast off

TOP LAYER

RND 1 using white crochet cotton, dc 7 dc in magic ring {7 dc sts}

RND 2 dc 2 in each st all round {14 dc sts}

RND 3 [dc 1 in next st, dc 2 in next st] all round {21 dc sts}

RND 4 [dc 1 in next 2 sts, dc 2 in next st] all round {28 dc sts}

RND 5 [dc 1 in next 3 st, dc 2 in next st] all round {35 dc sts}

RND 6 [dc 1 in next 4 st, dc 2 in next st] all round {42 dc sts}

RND 7 dc 1 in each st all round in back loop {42 dc sts}

RNDS 8–11 dc 1 in each st all round {42 dc sts}, cast off

BASE

RND 1 using white crochet cotton, dc 7 in magic ring {7 dc sts}

RND 2 dc 2 in each st all round {14 dc sts}

RND 3 [dc 1 in next st, dc 2 in next st] all round {21 dc sts}

RND 4 [dc 1 in next 2 sts, dc 2 in next st] all round {28 dc sts}

RND 5 [dc 1 in next 3 sts, dc 2 in next st] all round {35 dc sts}

RND 6 [dc 1 in next 4 sts, dc 2 in next st] all round {42 dc sts}

RND 7 [dc 1 in next 5 sts, dc 2 in next st] all round {49 dc sts}

RND 8 [dc 1 in next 6 sts, dc 2 in next st] all round {56 dc sts}

RND 9 [dc 1 in next 7 sts, dc 2 in next st] all round {63 dc sts}

RND 10 [dc 1 in next 8 sts, dc 2 in next st] all round {70 dc sts}, sl st

RND 11 ch 1, [2 htr and 1 sl sl in next st, 1 sl st in next st] all round, cast off

ICING

RND 1 using pale pink crochet cotton, dc 7 in magic ring {7 dc sts}

RND 2 dc 2 in each st all round {14 dc sts}

RND 3 [dc 1 in next st, dc 2 in next st] all round {21 dc sts}

RND 4 [dc 1 in next 2 sts, dc 2 in next st] all round {28 dc sts}

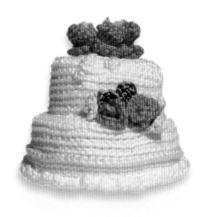

Wedding Cake

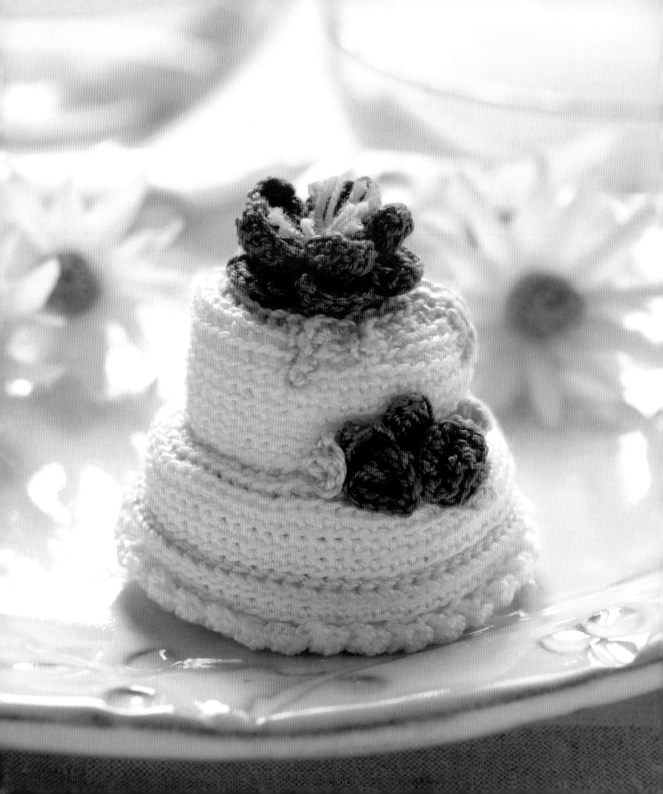

RND 5 ch 5, into 2nd ch from hook work dc 1, dc 1 into each rem. ch, dc 1 into next 2 sts

ch 3, into 2nd ch from hook work dc 1, dc 1 into rem. ch, dc 1 into next 5 sts

ch 5, into 2nd ch from hook work dc 1, dc 1 into rem. ch, dc 1 into next st

ch 3, into 2nd ch from hook work dc 1, dc 1 into rem. ch, dc 1 into next 5 sts

ch 3, into 2nd ch from hook work dc 1, dc 1 into rem. ch, dc 1 into next 3 sts

ch 3, into 2nd ch from hook work dc 1, dc 1 into rem. ch, dc 1 into next st

ch 6, into 2nd ch from hook work dc 1, dc 1 into rem. ch, dc into rem. st

sl st into first st to join. Cast off

FILLING

Using pale pink crochet cotton, pull a loop through one of the stitches of the 11th round of the cake, [sl st in next st] all round, cast off.

SMALL FLOWER

(make 2)

Using deep pink crochet cotton, ch 9, 3 dc in 2nd ch from hook, 3 dc in each ch across, cast off.

BIG FLOWER

(make 2)

Using deep pink crochet cotton, ch 5 and join with a sl st to form a ring.

RND 1 ch 3, htr in the first st of the ring (this will form a loop), ch 3 and make 4 htr in the loop, sl st in the first st of the ring

RND 2 ch 3, htr in 2nd st of the ring (this will form a loop), ch 3 and make 4 htr in the loop, sl st in the 2nd st of the ring

RND 3 ch 3, htr in the 3rd st of the ring (this will form a loop), ch 3 and make 4 htr in the loop, sl st in the 3rd st of the ring

RND 4 ch 3, htr in the 4th st of the ring (this will form a loop), ch 3 and make 4 htr in the loop, sl st in the 4th st of the ring

RND 5 ch 3, htr in the 5th st of the ring (this will form a loop), ch 3 and make 4 htr in the loop, sl st in the 5th st of the ring, cast off

BIG FLOWER CHART

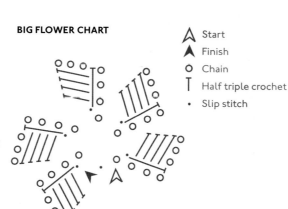

Stitch the two pieces together. If you would like to add the extra stamen details, thread a needle with yellow and orange crochet cotton and check the photograph of the final piece for stitch placement.

LEAVES

(make 5)

Make 2 leaves in dark green and 3 leaves in bright green. Ch 4, tr in the 4th ch from hook, ch 4, sl st in the very first chain, cast off.

TO MAKE UP THE WEDDING CAKE

Using a fine sewing needle and matching thread, stitch the icing on the top layer, with small stitches around the edge. Stitch the two big flowers on top. Stitch the top layer onto the lower layer, then pack the cake with toy filling until tightly filled. Stitch on the base. Sew the small flowers and leaves on the base layer, checking with the photograph of the finished piece to place them correctly.

A Start
A Finish
O Chain
T Half triple crochet
• Slip stitch

BIRTHDAY CAKE

These teeny pastel birthday cakes can be made in any shade – if you're feeling generous you could make a plateful in different colours for a friend's birthday.

YOU ALSO WILL NEED

- Small quantities of crochet cotton size 20-30 in white, yellow and brown, plus a pastel colour for the main body of the cake – the example shown uses blue as its principal colour
- Sewing needle and thread

CAKE TOP

RND 1 using blue crochet cotton, dc 7 in magic ring {7 dc sts}

RND 2 dc 2 in each st all round {14 dc sts}

RND 3 [dc 1 in next st, dc 2 in next st] all round {21 dc sts}

Birthday Cake

RND 4 [dc 1 in next 2 sts, dc 2 in next st] all round {28 dc sts}

RND 5 [dc 1 in next 3 sts, dc 2 in next st] all round {35 dc sts}

RND 6 [dc 1 in next 4 sts, dc 2 in next st] all round {42 dc sts}

RND 7 dc 1 in each st all round in back loop {42 dc sts}

RNDS 8-9 dc 1 in each st all round {42 dc sts}

RNDS 10-11 using brown crochet cotton, dc 1 in each st all round {42 dc sts}, cast off

CAKE BASE

RND 1 using white crochet cotton, dc 7 in magic ring {7 dc sts}

RND 2 dc 2 in each st all round {14 dc sts}

RND 3 [dc 1 in next st, dc 2 in next st] all round {21 dc sts}

RND 4 [dc 1 in next 2 sts, dc 2 in next st] all round {28 dc sts}

RND 5 [dc 1 in next 3 sts, dc 2 in next st] all round {35 dc sts}

RND 6 [dc 1 in next 4 sts, dc 2 in next st] all round {42 dc sts}

RND 7 [dc 1 in next 5 sts, dc 2 in next st] all round {49 dc sts}, sl st

RND 8 chain 1, [2 htr in next st, 1 sl st in next st] all round, cast off

CANDLE

RND 1 using white crochet cotton, dc 7 in magic ring {7 dc sts} (this is the top of the candle)

RNDS 2-9 dc 1 in each st all round {7 dc sts}, cast off

FLAME

Using yellow crochet cotton, ch 4, tr in the 4th ch from hook, ch 4, sl sl in the very first ch, cast off.

CREAM CIRCLE (AROUND CANDLE)

Using white crochet cotton, with the top of the cake facing up, pull a loop through one of the stitches of the 3rd round of the cake.[2 htr in next st, sl st in next st] all round.

Join to the first loop with sl st. Cast off.

TO MAKE UP THE BIRTHDAY CAKE

Using a needle and matching thread, and checking the photograph of the finished piece for reference, stitch the flame on to the top of the candle. Stitch the candle in the middle of the cake. Fill the cake and stitch the base piece in place. (See the note at the beginning of the chapter about using bottle tops as an alternative 'filling'.)

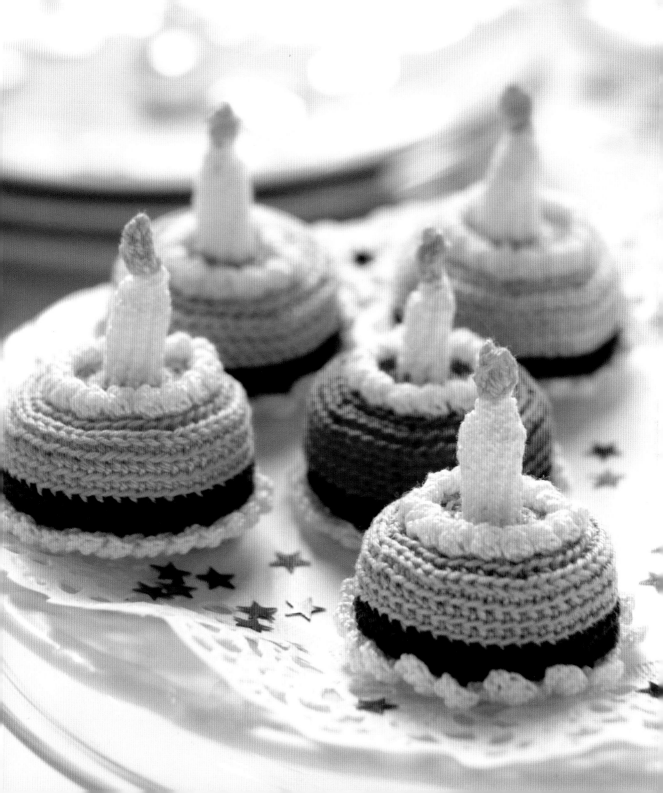

Index